S E E
F O R
Y O U R
S E L
F

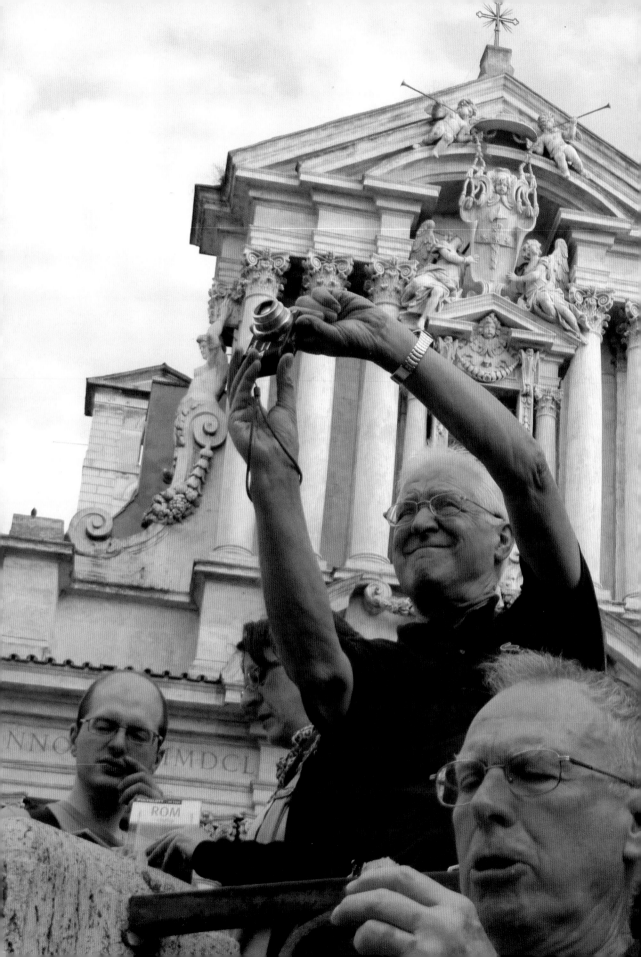

SEE FOR YOURSELF

A VISUAL GUIDE
TO EVERYDAY BEAUTY

BY ROB FORBES

CHRONICLE BOOKS
SAN FRANCISCO

ACKNOWLEDGMENTS

There are a lot of people to thank for helping me with this book. At the top of the list would be the personal teachers and friends who helped me appreciate form and visual thinking in our modern world: Michael Cardew, Hardy Hanson, George Nelson, and Ralph Caplan. My appreciation for the design of urban environment should credit many thinkers and writers, with Lewis Mumford, Jane Jacobs, and Jeff Speck being most notable. A flock of people have helped me with the writing of this, dating back fifteen years to Design Within Reach, and they include Owen Edwards, Dan Shapiro, Brenda Natoli, Dung Ngo, Cathy Ho, and Samantha Topol. Other friends who have assisted along the way include Jon Gasca, Giulio Lazzotti, Lawrence Wilkinson, Kelly Sultan, Scott Maddern, Erik Spiekermann, Ted Boerner, Dan Nguyen-Tan, and John Willis. The Chronicle publishing team includes Brooke Johnson, Erin Thacker, Caitlin Kirkpatrick, Leigh Saffold, Bridget Watson Payne, and Mark Burstein. And a special thanks to Leslie Carol Roberts and Stephanie Vernier, who helped me guide this to completion, along with designers Eric Heiman, Bryan Bindloss, and John Provencher at Volume Inc.

Library of Congress Cataloging-in-Publication Data available.

ISBN: 978-1-4521-1714-0

Manufactured in China

Design by Volume Inc. / www.volumesf.com

10 9 8 7 6 5 4 3 2 1

Chronicle Books LLC
680 Second Street
San Francisco, CA 94107
www.chroniclebooks.com

CONTENTS

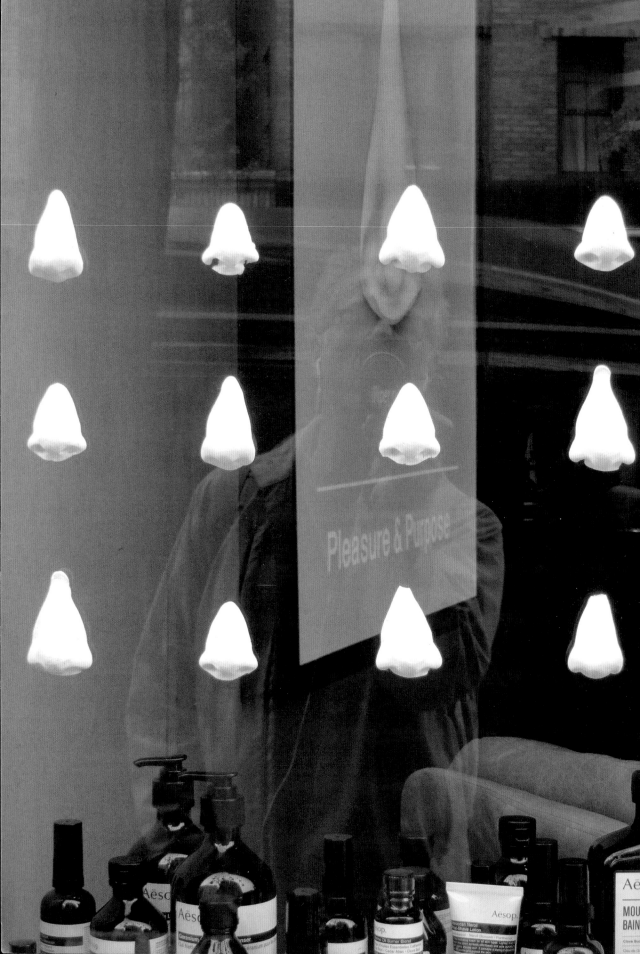

INTRODUCTION

"Seeing. One could say that the whole of life lies in seeing—if not ultimately, at least essentially." —Teilhard de Chardin

Ten years ago, I came upon a bin of nail polishes in a Seoul shopping mall. Why did I stop to take this photo? Perhaps it was the mad pile of ecstatic colors, maybe it was the angles of the white caps, or it could have been the fact that this random collection of cheap, trendy enamels offered a moment of pattern, angle, and color superior to everything around it. I create visual diaries of all my wanderings; my mind is wired for this practice—and for me, good design can be found equally in the billowing sheets hung to dry on an Italian side street as in the New York Museum of Modern Art collection.

Other examples of how I see: In Milan, a street vendor's pile of wooden letters on wheels and toys caught my eye. Delightful. Recently, I came across this crate of seafood scraps in a fish market in Panama City. Perfect. The world is filled with arrangements, tossed together with either conscious or unconscious concerns around aesthetics. And occasionally these arrangements have curious and compelling visual similarities.

Why does my mind make these connections? They come organically to me, but I guess the common threads in these cases are random groupings of small objects, a mix of hard and soft edges, and a dense pack of visual tidbits with dramatic visual energy within each grouping. More important, they are all everyday, unpretentious piles of stuff in marketplaces. Furthermore, while these arrangements were found in diverse cultures, separated by thousands of miles, the similarities in the visual patterns give me pause. While red highlights tie these images together visually, each is a story about a specific place and point in time, each has a cultural narrative behind it. The more we observe with care, the more associations and patterns and stories we create for ourselves. Close observation is like any exercise, physical or intellectual or spiritual. The more we see, the more we see.

This book has a simple premise: By paying closer attention to the man-made world, we become more insightful and more engaged, and we have a little more fun. One of nature's finest gifts to us is light—how it bounces off things that make up our world and how our eyes have a way of capturing it. And we should make the most of it. We can learn to be more discerning observers, able to dismiss or protest the things that interfere with our visual experience as well as disrupt our culture. We can have mysterious visual encounters that leave us without any rational or verbal explanation; we can have quiet moments of curiosity and engagement that are ours, and ours alone.

This book is also a chance to have a conversation with people interested in engaging with what we see. *Engaging* is perhaps too strong a word—what I mean to say is, this book is a collection of thoughts and reflections and images, a place to slow down and speculate on the beauty, humor, texture, and meaning of everyday life.

In Rio de Janeiro, a street pattern caught my eye. In this case, the pattern asked me to think critically about the design issues associated with a sidewalk, a topic of keen interest and study for me. Designed by

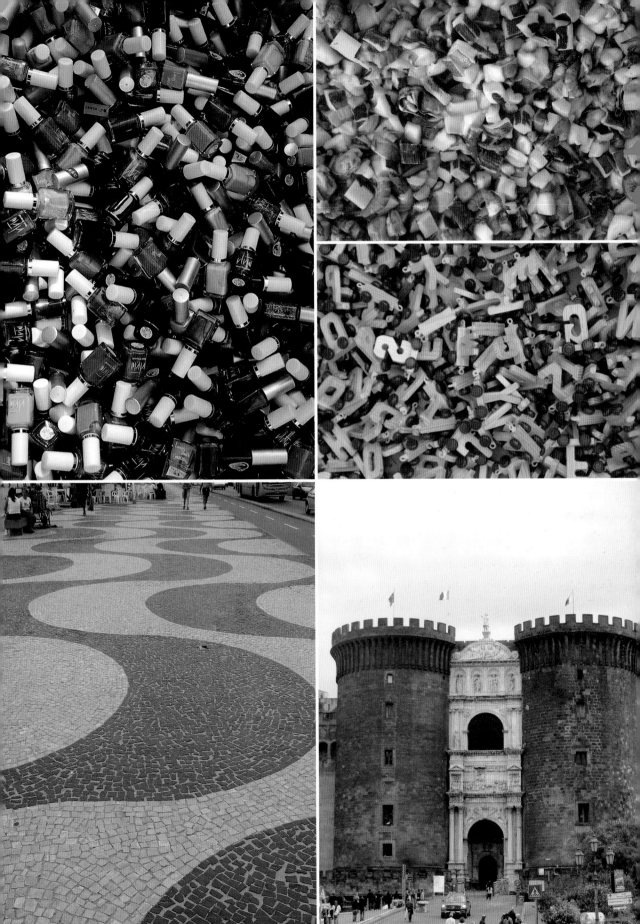

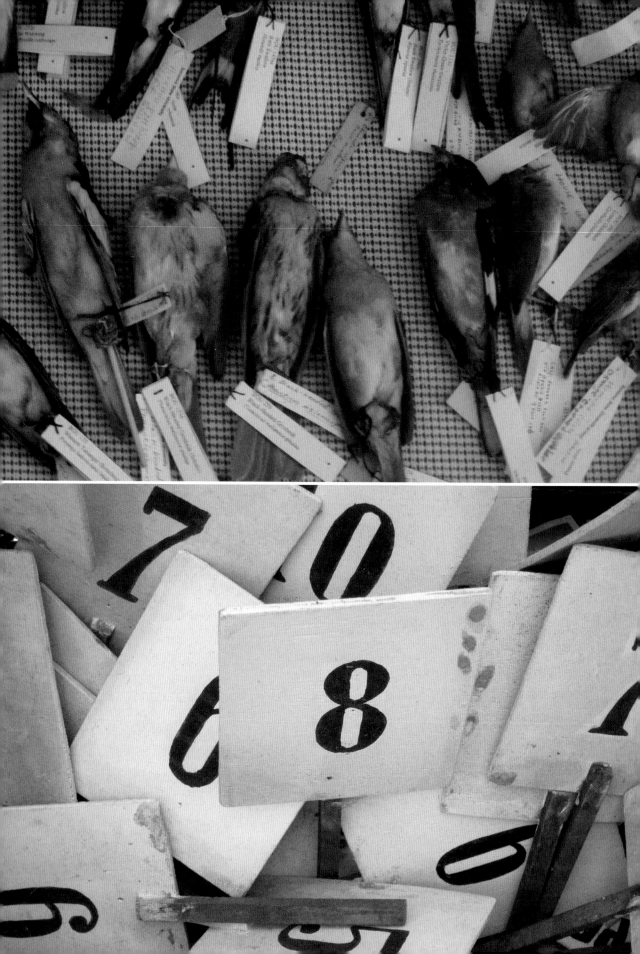

Every object and arrangement surrounding you right now offers some value if you really see the meaning behind it.

Oscar Niemeyer and Roberto Burle Marx, this sidewalk stretches along the famed Copacabana beach; it defines Rio as much as the more acknowledged Cristo and Sugarloaf icons or "The Girl from Ipanema." Our sidewalks—and what we see in them—say a lot about our culture and its values. This is an intentional piece of public design, more than an anonymous public-works project, and entirely consistent with Brazilian values and culture—flowing, lyrical, and lush—samba rhythms of design for everyone to stroll over.

This sidewalk also taught me to see in a new way. What about our sidewalks and their meaning? And so I began looking down when walking. I soon decided something this common was uncommonly critical to our urban well-being. The best cities tend to have the best sidewalks—or the equivalent best pedestrian zones. They might be the defining feature of a civilization or democracy—how we design, build, and manage the common places where all segments of society congregate with equal access.

From the moment we wake, we read, listen, hear, touch, taste, and smell. And yet the overwhelming majority of our opinions are made through visual assessment. Studies to determine the exact percentage of our comprehension based on visual information have had varied results, though estimates typically fall between 70 percent and 80 percent. These statistics are debatable, but there is empirical data that we often close our eyes when we kiss a lover for a reason. With open eyes, our minds begin to process what they perceive, activating cognitive functions and the thoughts they bring. When we meditate, go into hypnosis, or sleep, eyes close. There is just too much going on out there to distract us.

When we do have our eyes open, we are usually looking but not really *seeing*. I wrote this book to encourage each of us to develop stronger visual conversations with the world. While looking at the natural world—cellular structure under a microscope, or a field of flowers, or gazing at stars—we can teach ourselves how to appreciate proportion, enjoy color, learn about composition, and be more acute visual thinkers. But the images in this book invite us to see what we create as human beings. Everyday objects dominate—things not inherently pretty or beautiful on their own, but things turned into something compelling by the way they are arranged or how we compose a picture of them. These artifacts of the built environment can engage and amuse and give insights into humankind and the world we fashion for ourselves.

This book is compiled from photographs I've taken over the past ten years during walks through cities and towns, frequently in Europe, and often in cities known as cultural design centers: Milan, Barcelona, Amsterdam, Paris, and Copenhagen. During this period, I was searching—"shopping"—for designer goods to import and sell at Design Within Reach, a company I founded in 1999. Our mission at DWR was to make modern design more accessible in the United States. And Europe, Italy especially, was a rich source of design unavailable in North America. After a number of years, however, the shopping for design products became more or less predictable. Showrooms and exhibitions looked new each year, but the newness was largely due to exercises in styling and fashion. Most new products were derivative of earlier works.

As the shopping became more predictable, however, walking the streets became more exhilarating. Instead of shopping the stores and showrooms, I began shopping the streets, looking for things that carried some cultural meaning, insight, or amusement. I looked at everything around me more closely, and with greater curiosity. I found myself admiring simple things, like napkins in cafés, windows, street signs,

And yet the overwhelming majority of our opinions are made through visual assessment.

left
NAPLES
DEER ISLAND

right
NEW YORK
MILAN

14

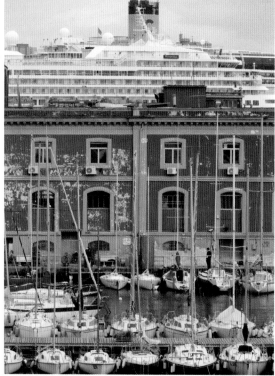

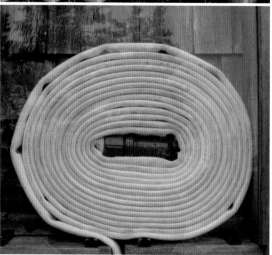

bikes, doorknobs, benches, tiles, guardrails, mailboxes, garbage cans—anything and everything, except things highlighted in tourist guides.

Soon I found myself shopping the streets of lesser known smaller cities and towns in Europe, in the United States, and everywhere I traveled in the world. I took many photographs along the way. I began musing over and sorting through these images, often finding amazing visual connections, like stuffed and labeled songbirds in Sonoma, California, that shared graphic sensibilities with signs I found in a flea market in Arezzo, Italy. Coiled fire hoses became riveting studies in color, materials, and restrained power. A port scene in Naples, Italy—a visual sandwich of a historic building trapped between older sailboats and contemporary cruise ships—became a study in form and a metaphor for the complexities of our modern world. I found contrasting examples of generous and dangerous public seating. Richard P. Feynman's "Nearly everything is really interesting if you go into it deeply enough" became a mantra. It is probable that every object and arrangement surrounding you right now offers some value if you really see the meaning behind it.

It was also during this time shopping for DWR that I stumbled across a small book titled *How to See* by designer George Nelson. The book was written initially for the U.S. Department of Health, Education, and Welfare in 1973 to help educate government workers in how to see and think more clearly. Nelson's iconic lamps, benches, and furniture designs were mainstays at DWR. And while I'd read some of Nelson's other writings, this book was new to me. It was a modest seventy-two-page pamphlet with faded black-and-white photos, obviously done under a tight budget. It was on the opposite side of the spectrum from a lavish art or design publication, but the ideas communicated were greater and more provocative than those in any art or design book I have ever read on the subject.

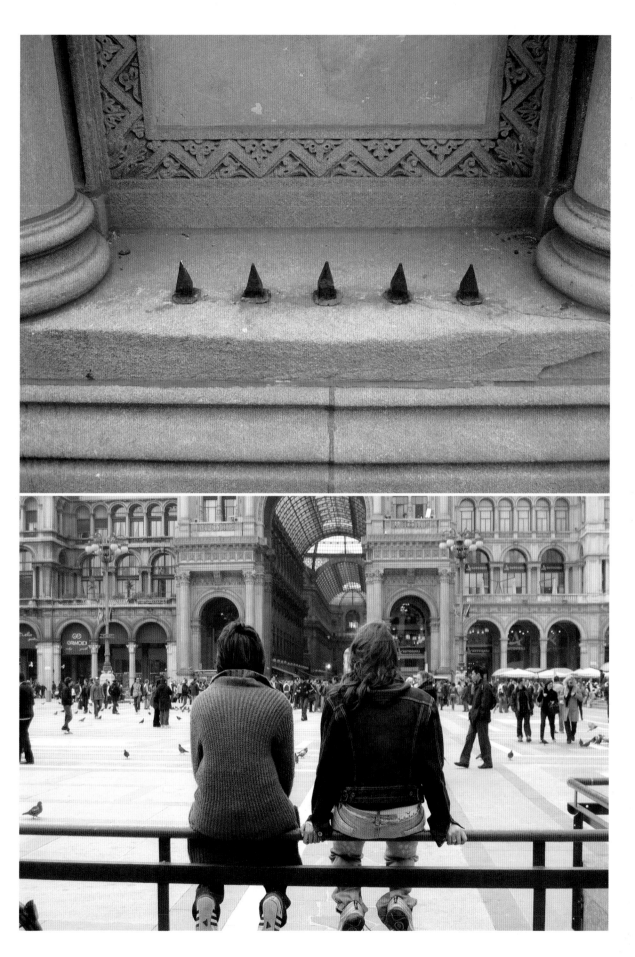

The best cities tend to have the best sidewalks.

The fact that Nelson had taken on this project of educating civil servants was equally inspiring. The 1973 pamphlet led to a larger 1977 publication that Nelson did for the broader market, which includes a group of essays and insights derived from looking carefully at the world and taking photographs. It was published by Little, Brown and Co. with an added subtitle: *Visual Adventures in a World God Never Made.* I had the great pleasure and honor of updating and republishing this edition through Design Within Reach in 2002, now subtitled *A Guide to Reading Our Man-Made Environment.*

Nelson became something of a role model and mentor to me, and his distinctive way of finding patterns and meaning in the modern built environment is and was unprecedented. So was his humor and lucid articulation in writing. Seeing, as Nelson defines it, is a discipline, and I have found it to be equally fun, addictive, and meaningful. It is not about a search for "perfection." When I am out looking at things and collecting images, I am responding quickly and intuitively to what is interesting, honest, quirky, and common, rather than what I believe will look "good" or reflect some aesthetic ideal. To wit, none of the images in this book has been Photoshopped, color corrected, or enhanced to make them more pleasing. And this is good enough.

Of course, not all of what we see on the streets is rosy pleasure. Much of the man-made world I see is chaotic, random, banal, offensive, and frequently punished by the commercial interests of our consumer world. In efforts to make our lives more convenient and "modern," we have made both great accomplishments and tragic errors in judgment. Surface-level downtown parking lots, undistinguished strip malls, and suburban sprawling communities are common examples. Our man-made world has suffered to a large degree because we simply have not taken the time to look at it closely

and think about the consequences of our actions for the long term.

But there is nevertheless a certain optimism for me in focusing on the built environment; it is a world we can do something about. We can rearrange chairs, paint buildings, build streets and bridges, place benches, set tables, select what mode of transport we take every day. (We cannot create order in nature, as much as we might dam it up or try to control it.) In order to make a difference in how we live in this world and share it with other people, I believe we have to first see it and understand it. There is an art, a practice, to seeing that is available to anyone with curiosity and a recording device (and I have found that a basic camera is much more convenient and tolerant to me than a sketch pad).

Many things in life, including our meaningful visual experiences, cannot be fully explained in words or logical thought. Try to describe truth or beauty or love in words and you won't get very far. The experience itself and the creative, poetic part of the practice is what really matters. I heard a brilliant behavioral scientist state that as human beings we are fundamentally creatures with deep feelings who have learned to think, rather than thinking creatures who have learned to feel. Western scientists and engineers would probably disagree. Descartes's maxim "I think, therefore I am" is still a popular way for many to view and value our human nature and capabilities. But it seems flawed to me. The practice of seeing is more about learning to feel what is around us—colors, textures, contrasts—than it is to comprehend them rationally. The French priest and paleontologist Teilhard de Chardin stated that "analysis dissects all things and lets their souls escape." I think this is true, and it might render all of my words in this book as footnotes to the images. With each image there is a visual narrative and some cultural insight, but the meaning of each is highly personal and subjective.

Exercising seeing is the way I make sense out of things. It is both how I engage with the world and my best psychic and emotional defense against the aspects of the world that trouble me. Seeing prompts me to think about changes that can improve our built environments and communities. Often I find a story that makes me more curious about the environment we have created. Sometimes I find a sublime composition and beauty. These are my reasons, but you might find a much better reason to look at the world. *See for yourself.*

——————————

——————————

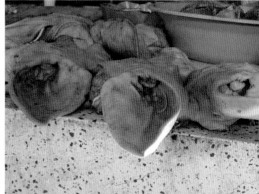

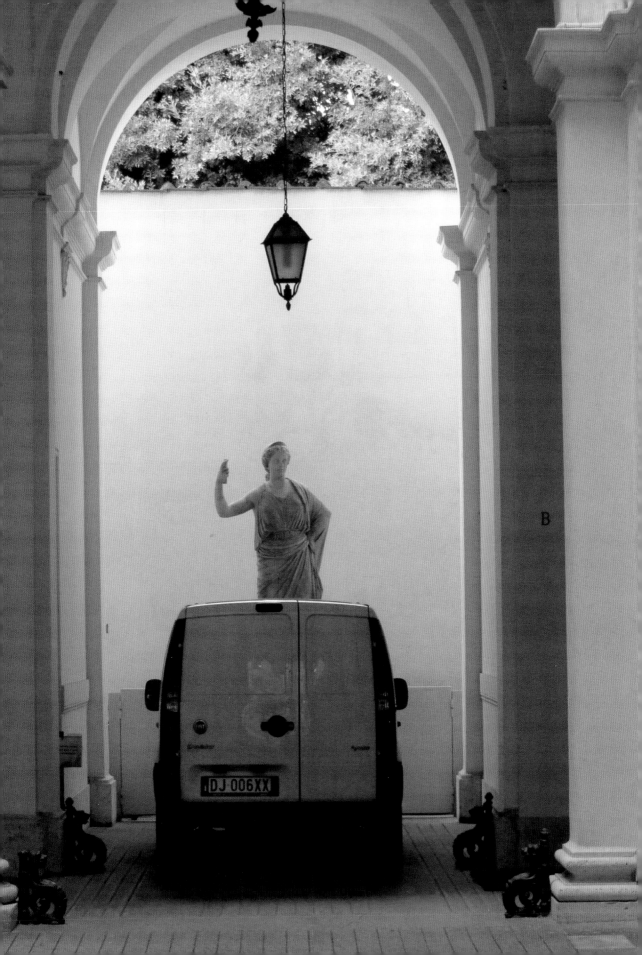

ANGLES

————————
————————

"Use curves for beauty and angles for strength."
—Bernard Leach

When I was a ceramics student, I came across this quote by the famous British potter Bernard Leach. As simple as it seems, the concept has stuck with me and proven its relevance time and time again. Compare an oval to a triangle: Which has more elegance and which has more power? A construction scaffolding structure in Buenos Aires makes a strong visual composition as a result of the angular braces, which serve to give it support physically (and the yellow patches help to keep your eye moving).

From teepees to pyramids to staircases to bridges—architects and builders and engineers have relied on angles for eternity for their strength and character.

The world around us is shaped by right angles: Our living and working structures have flat ceilings with perpendicular walls. Our rooms are boxlike. Many of us live in communities based on grids. The sheets of paper we read, monitor screens, shelves—they are all fundamentally composed of right angles. These ninety degrees define much of our modern and postmodern lives.

Maybe this is why "wrong angles," such as obtuse and acute angles, interest and attract me—they invite curiosity, like this wall and doorway in Colonia, Uruguay, where the ivy's angle, attaching to this wall and door, turns a common building into a provocative statement. The fact that half the design was engineered by nature, the other by some human being, also helps make this composition unique.

Angles often carry motion (arrowheads), force (building trusses), vitality, and verve. Rotate a square forty-five degrees, and it takes on enough attitude to become a warning sign.

I would not have paused to photograph a guy in the Bonneville Salt Flats in Utah had it not been for the dynamism of the angles in composition: the arms, hat, and overalls. Even his head is slightly cocked. The angles contrast with his soft body and also with the flat horizon. The power of angular body features is not lost on the fashion industry, which is why pronounced cheekbones and narrow waists leading to broad shoulders are commonly employed, and why mannequins are often studies in angles themselves.

Sharp, persistent angles without repose can be jarring or aggressive and unsettling, and purely round forms (circles) are usually boring. However, what we find in the tension between these two forces is quite compelling. See how beautiful hard angles are when softened with age and juxtaposed with the curved columns from a wall in Parma, Italy. Arches are excellent examples, as they blend angles and curves in a magical and profoundly useful manner.

Angles put us on alert, which is why graphic designers slap forty-five-degree-angled banners on magazines or websites. Many road signs are on angles for a reason. Angles probably do not make pizza or pie taste better, but they make it an adventure to pick up and eat.

————————
————————

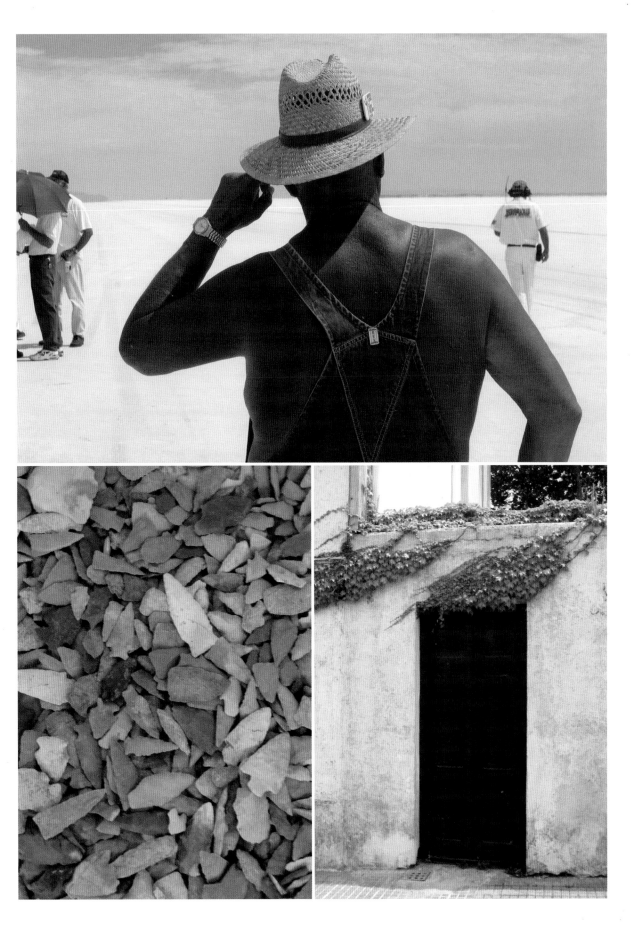

Angles put us on alert.

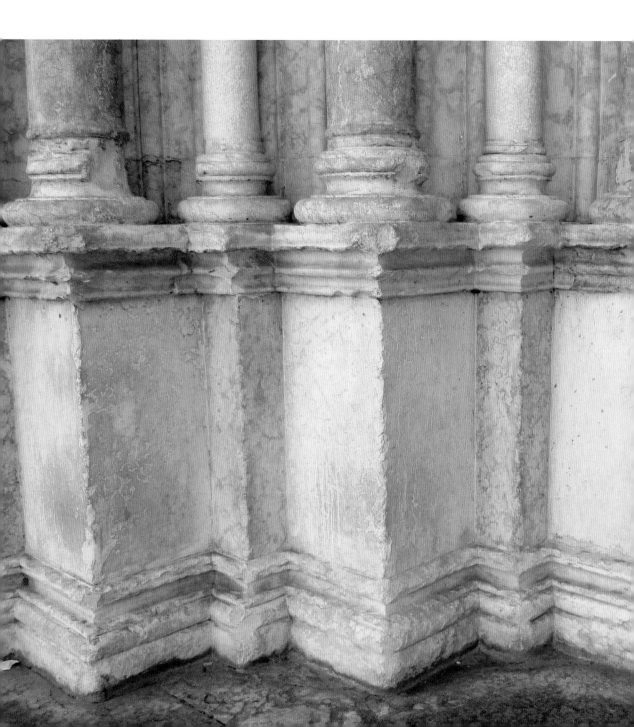

left
PARMA

right
MARIN
PARMA
GLEN ELLEN

next
TORRITA DI SIENA
SCOTTSDALE

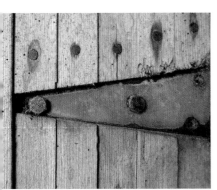

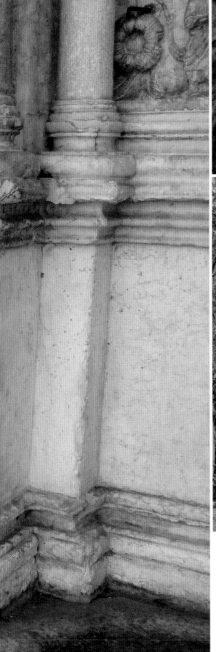

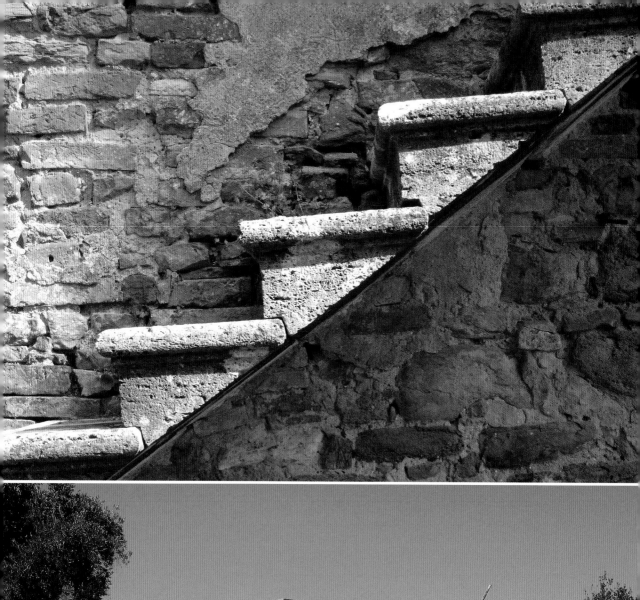

TILES
LISBON, PORTUGAL

I found an astonishing range of tiles while walking Lisbon's alternately narrow and wide streets—a spectrum of pattern and color—decorating houses and public buildings. Embellished buildings often take on a dated or nostalgic or silly look in our modern world. Yet these tiles feel natural because many of the patterns are deeprooted in cultural traditions that have evolved over centuries. They tell stories that continue to resonate—of a time when heightened public awareness about civic appearance and the willingness to have some fun added delight to urban life.

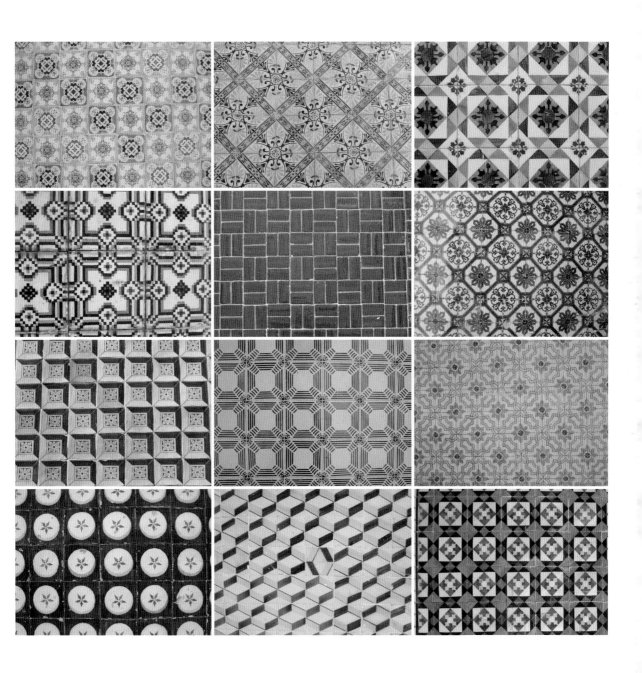

COLOR

Color is often the first thing that draws my eye for a longer look.

It latches onto form and confidently stakes out its territory. That's power. And a little bit can go a long way. I would not have noticed this mailbox in Croatia had the yellow not been whistling to me. When used unexpectedly, as with the vibrant blue on these trees in Argentina, it will get your attention. Its appeal spans cultural biases: the Golden Gate Bridge is a world-recognized icon thanks to its bold vermilion surface (officially, a reddish variant of "International Orange").

Other visual elements like shape and proportion can be measured and quantified; color does not work that way. Our response to color is emotional, irrational, and highly personal. Color provokes a response from us—from a little hint to a loud demand. I picked a specific shade of red for the Design Within Reach logo. How different the company's identity would have been if the logo had been green. How different IBM would be if it had a red rather than blue personality.

Volumes have been written about color theory as a science. While this approach is interesting, it's not that useful to me in actually understanding how color operates in the world. We see a lemon as yellow, but

it isn't yellow according to the science of perception. Apparently it is everything except yellow, but yellow is what gets reflected back to us. For me, this type of analysis just makes the subject more obscure. I learned more about color in a course I took from a Josef Albers disciple than I have from any scientific or analytic study. It helped me appreciate the basic assumptions of what we see, or think we see, in any color at any one time. For example, the way we interpret any color depends enormously on what color is adjacent to it. This is a fundamental fact, but few of us are aware of it. Albers's _Interaction of Color_ is a terrific guide to understanding the fundamentals of color and how to apply them. (Originally published in a limited edition by Yale in 1963, today it is available in a variety of formats, from paperbacks to an iPad app.) But you might better learn to appreciate and understand the power of color by sitting silently in Chartres Cathedral or your neighborhood house of worship and looking at the stained-glass windows, or noticing the effect of red lipstick on lips, or the impact a small garnish of green parsley can have on a plate.

Color blows your cool. There is a reason why nuns (and designers) prefer to dress in black (the absence of color), as it keeps our emotions in check and might encourage us to think about other more rational and serious issues.

Less industrial cultures indulge more freely in color. I stumbled onto some extraordinary multicolored work sheds on a rural island off the coast of France. In many cities and regions in France, the color of buildings and roofs is strictly regulated, making these shacks all the more amazing. In cities like Oaxaca, Mexico, or Cartagena, Colombia, color screams at you from every angle. In most North American cities, that's not the case. Bright color is a tool deployed to demand our

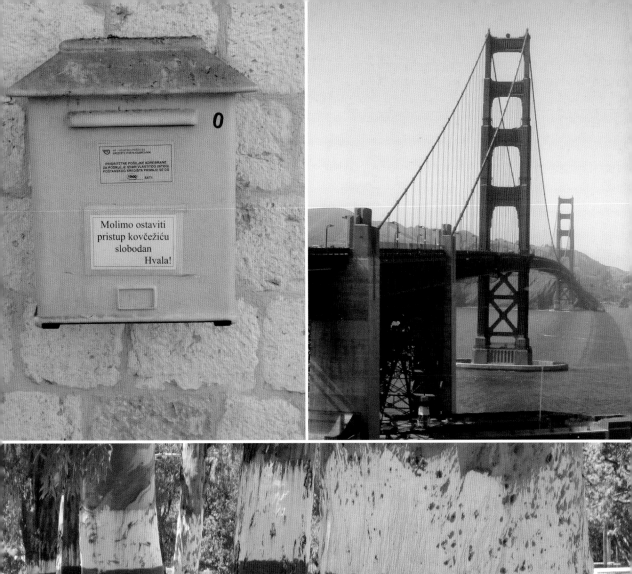

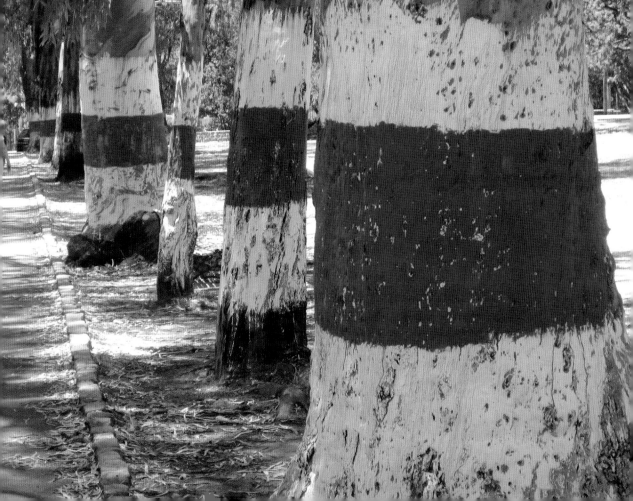

33

far left
PANAMA CITY

left
VENICE

right
HAVANA
ROME

next
CINQUE TERRE
VENICE

attention: stop signs, taxicabs, fire trucks, nail polish, and power ties.

Red is a controlled substance in Brazil; red cars are illegal based on the argument that it makes drivers too aggressive. Red also works magic on children: McDonald's and all fast food chains know this well and use bright primary colors, red especially, to excite the visual senses, just as sugar is used to excite (or manipulate) the physical senses. As adults we seem to opt out of this manipulation; witness our preferences for gray and black cars, beige buildings, and other subdued tones.

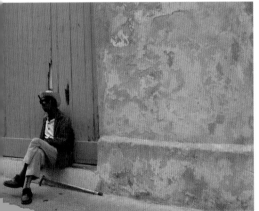

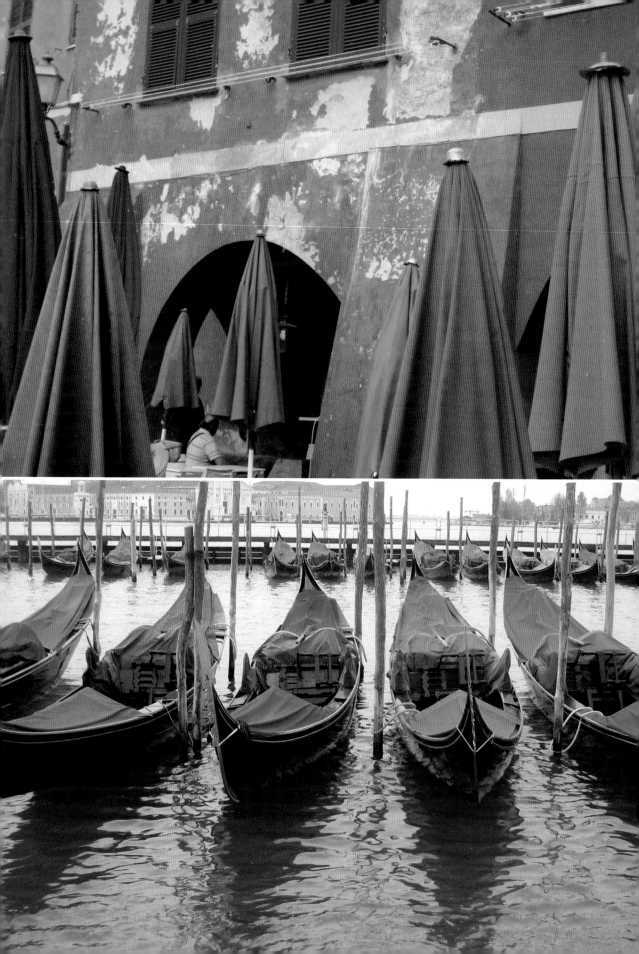

OYSTER SHACKS
ÎLE D'OLÉRON, FRANCE

I was visiting my stepmother on an island off the coast of France known for oyster farming. The gray landscape was largely flat, nondescript, and marshy with muddy creeks. These bright-colored shacks, work sheds used for storing equipment, popped up in one village. So playful! Like folk art, they were somewhat naïve. Simple blocks of color on simple shapes, like Monopoly houses. What was the inspiration for the color? Does the color carry any meaning? Who knows? It's good enough that it just increases our sense of curiosity and visual pleasure.

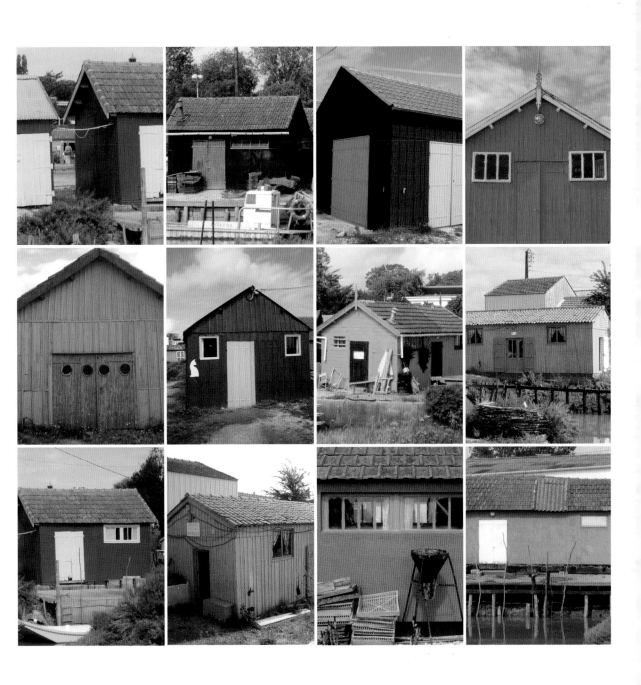

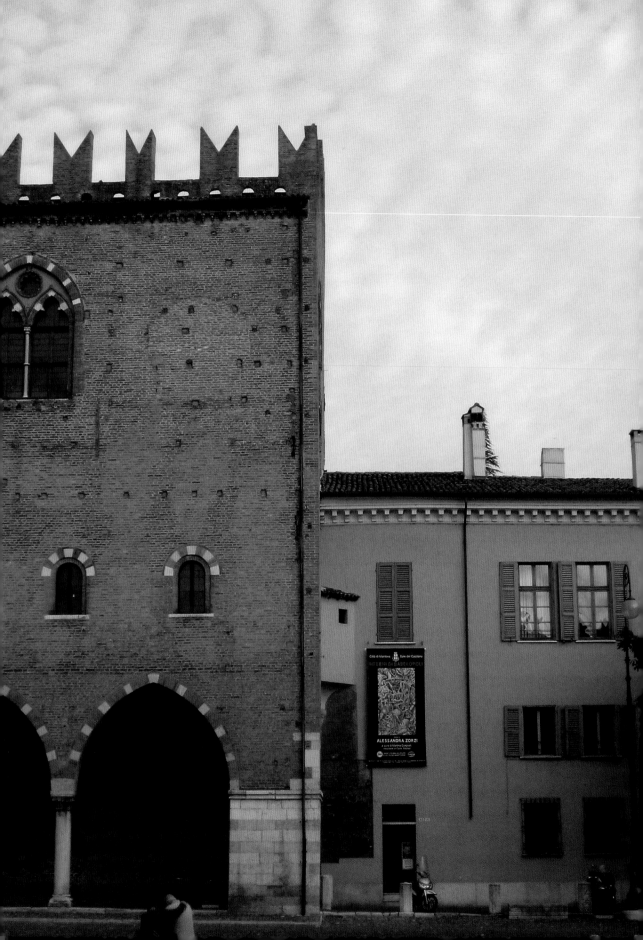

CONTRAST

previous
MANTUA

left
PIENSA

right
PANAMA CITY
PIETRASANTA

38

————————
————————

Contrast defines our existence.

We experience it every day, a seamless flow, metab-
olizing experience and setting comparisons—often
unconsciously. There is no night without day, good
without bad, cold without hot, loud without quiet,
yin without yang, kitsch without elegance, and so on.
Nothing exists in isolation.

However, sometimes we need a wake-up call in the
modern built environment to appreciate the power of
contrast, like these structures in a small town outside
of Lucca called Pietrasanta in the northwest corner of
Tuscany. It's one of my favorite examples of contrasts in
the built environment.

Recessed above a modern-looking ground floor
is an enclosed medieval balcony, perched there almost
comically, the weight of the ages crushing down on our
modern world. Here is a collision of histories, aesthetics,
intentions, materials, colors, and proportions. The multi-
ple brick arches, all a little different in size, contrast with
the rectangular wood-framed windows with shutters.
Angled cream-colored fabric awnings contrast with
the flat blue construction tarps. Earthy textured-stone
surfaces contrast with the creamy smooth yellow walls.

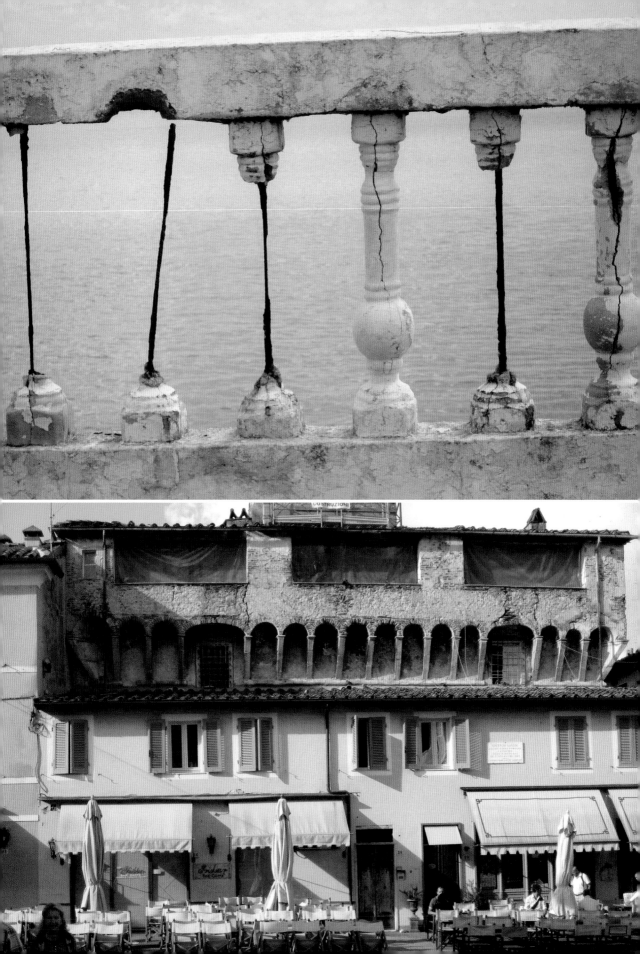

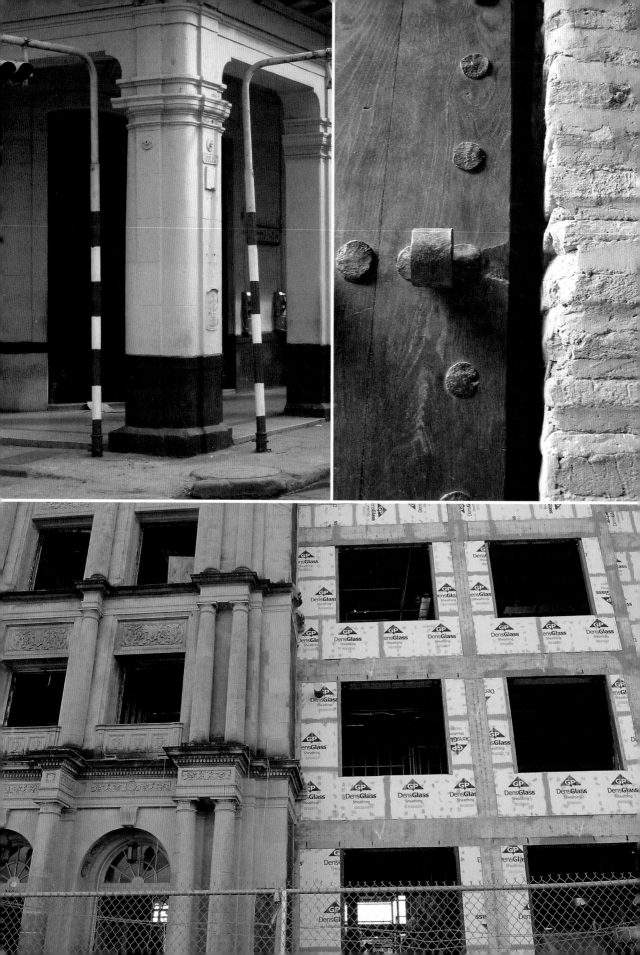

41

far left top
HAVANA

left top
GRENADA

left bottom
NEW ORLEANS

right
COLONIA
TAIPEI

next
VALS
PARMA

And these differences prompt questions and curiosities: We know the function of the newer building, but what about the older one? Are those arches structural, or decorative, or both? Who built it and what went on there?

When I returned to this same piazza a year later, the older building was cleaned up and stuccoed over in preparation for a paint job to match the building below. What a tragedy—great contrasts ought to be preserved. We need them to keep us on our toes.

This street corner in Havana is a more subdued, but no less compelling, example of contrasts in architecture—from banding on the columns, to the slender metal poles, to the contrasting solid masonry columns. Evenly spaced candy-cane-red stripes juxtaposed to subtle pink and brown tones. Thick versus thin. Curves versus straight lines.

When we're on the street looking around, a visual juxtaposition often urges us to halt. I'm partial to seeking out contrasts in everyday objects we often overlook—like these trash receptacles in Uruguay. The quirky but effective metal-framed structures line many smaller streets; particularly in their own right, when placed next to modern plastic receptacles, they tell a story not only of material and form but also of how we choose to publicly address refuse. The contrast seen in decomposing railing supports in Panama City tells an equally interesting story about age; they also expose the hidden infrastructure of the columns, reminding us not to take things at face value, or to realize that all surface decoration relies on a functional infrastructure, or maybe that nature inevitably will win out over time.

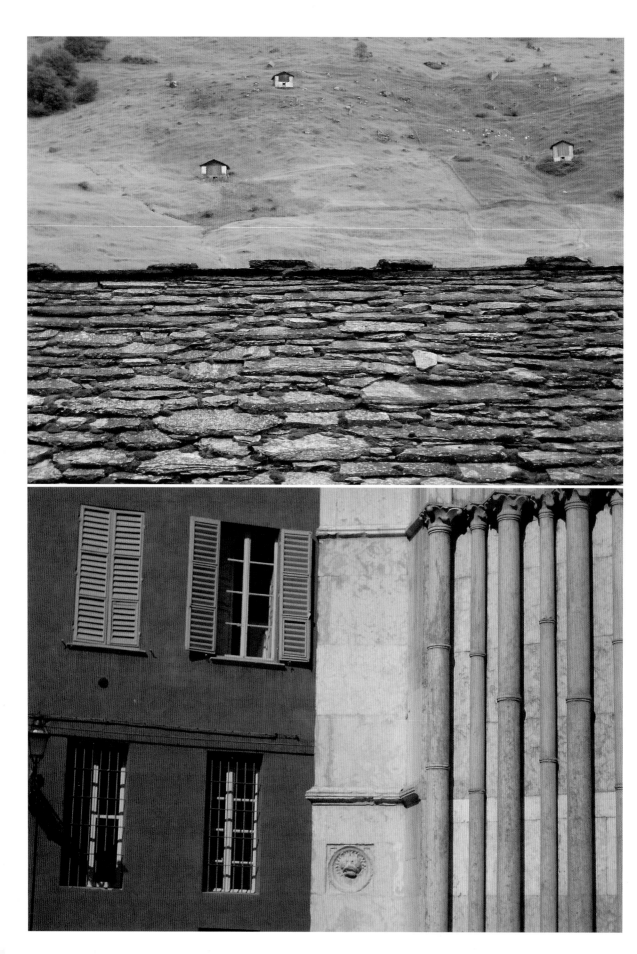

COLLECTIONS OF OBJECTS
AREZZO, ITALY

We are educated to be mindful of visual details in the Uffizi in Florence, standing in front of *The Birth of Venus* (as with any and all Renaissance fine art in Italy). Why not focus that "museum mindfulness" at the flea market?

The flea market in Arezzo, a former Etruscan town just down the road from Florence, like any good flea market, is one of life's gentle delights. The range of everyday objects is exceptional and jammed with compelling compositions. Cast your eye over the vivid materials and textures—take in the forms and patterns, materials and histories. This is an experiment in seeing, wonder, and delight with a narrative as rich as any museum's.

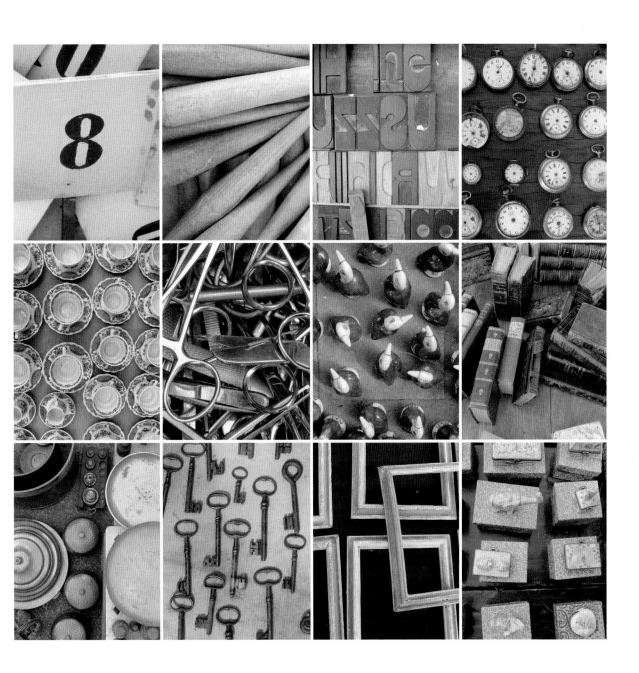

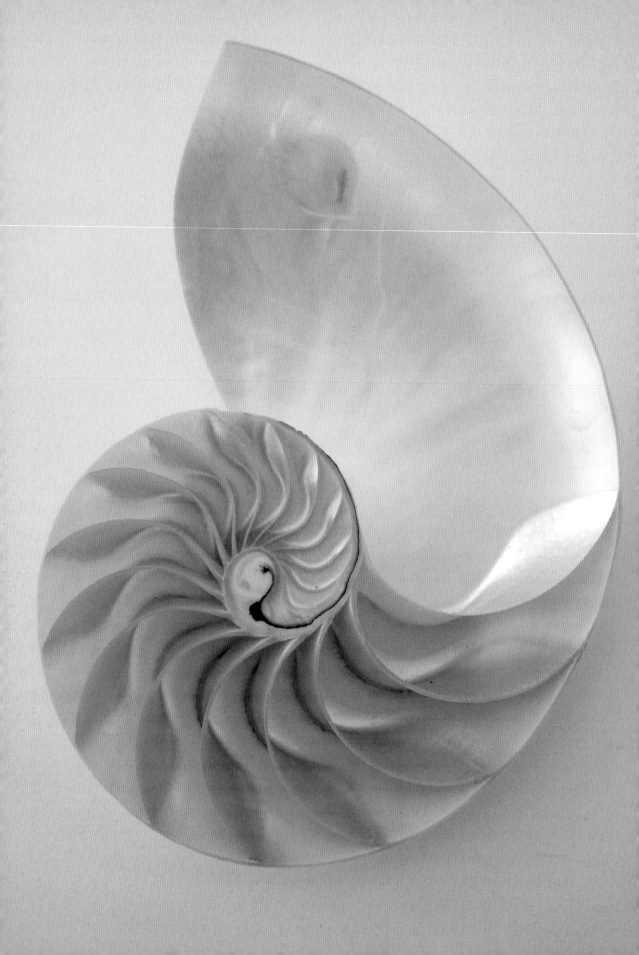

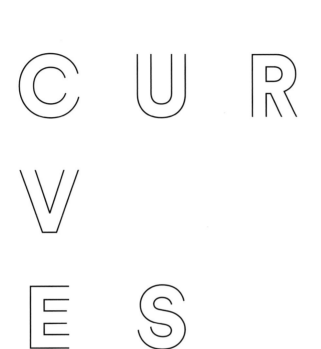

My first association with curves is with beauty and the sensuous side of form.

Is there anything more beautiful than the curved form of musical instruments like cellos or violins or tubas? Sure. One could find equivalent or greater beauty in a tree, a bird, the human body, or any other of nature's creations, but they all share in having some curvaceous form. While common in the natural organic world, curves are less common in our man-made constructs, which are ever increasingly rectilinear.

Curves have a kind of magic and can exert an exceptional force on us. For example, every day I pass by scores of tourists in my neighborhood lined up for blocks in traffic for a thirty-second drive down Lombard Street, "the curviest street in San Francisco." That wait seems ridiculous. But I will make pilgrimages across the state and around the world to my preferred curvaceous destinations, which include the Pantheon in Rome, the Guggenheim in New York, and the coastal road in Big Sur.

Many of the best aesthetic and functional design solutions incorporate curves, and I think in fact that it's the tension between linear and curved elements that makes them so successful. Take any well-designed bike, car, plane, bridge, or shoe, and you'll find a balance of

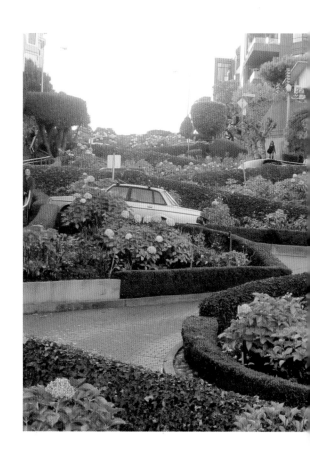

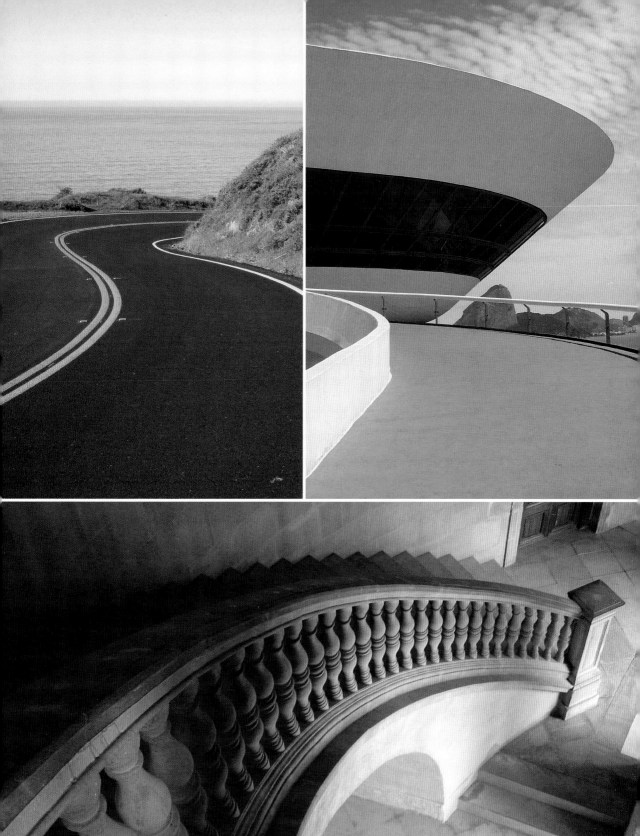

49

far left top
SÃO PAULO

left top
BARCELONA

left bottom
LOS ANGELES

right
PANAMA CITY

next
AMSTERDAM
CHICAGO

straight lines and curves. Remove the curved corners of your smartphone or laptop and see how less pleasing it is. A balance of curves and lines can turn dangerous razor-edge barbed wire or an aggressive piece of drilling equipment into a pleasant sculptural form.

I lived in London for a few years. It's a place where curves are a part of everyday life and orientation. The city evolved organically without intentional urban layout or design. There is no grid or logic to the layout, and I was constantly disoriented, frustrated, and lost in the city's maze of winding streets. The curves were maddening, and it was always a great relief to return to New York or Paris and rational topography. On the other hand, curves in the Brits' common form of traffic roundabouts created a movement and flow, and there is such sensible pleasure in not having to come to a full stop at intersections. Curves are elusive and wavering and, depending on where you intersect with them, can take you up or take you down.

Some cultures have more curves in their DNA than others, and Brazil is at the top. Curves come out everywhere in Brazil—even in phone booths, buildings, and furniture. And they exert a magical force and help shape the cultural psyche. The curvaceous sidewalk pattern of Copacabana in Rio de Janeiro is almost a perfect encapsulation for me of Brazilian culture. It stretches for several miles along the beach like an urban canvas. And it would be entirely out of place in Northern Hemisphere cities like Copenhagen, Berlin, Paris, or New York.

HANGING LAUNDRY
CROATIA

Laundry strung out windows, across alleys, draped on rope lines festooning gardens—all are common in many Mediterranean countries, where the sun and wind know how to dry garments and linens. On a bike ride around Croatia, I was struck by the way that drying laundry offers gentle visual studies in color and texture, quirky still lifes, colored textiles contrasting with ancient backdrops of stone and tile, some suspended like personal flags or banners. Laundry is just what it is—personal, often beautiful, and totally devoid of pretense. We have ordinances against displaying laundry in public in most U.S. cities, as it is considered "unsightly." Look up at roofs in any American city or town and you see crowds of ugly gray forms called satellite dishes, the sky speared by antennas. Meanwhile, our colorful laundry goes from machine to machine to closet and dresser or comes home from the cleaner's shielded in a blue paper wrapper or a plastic garment bag.

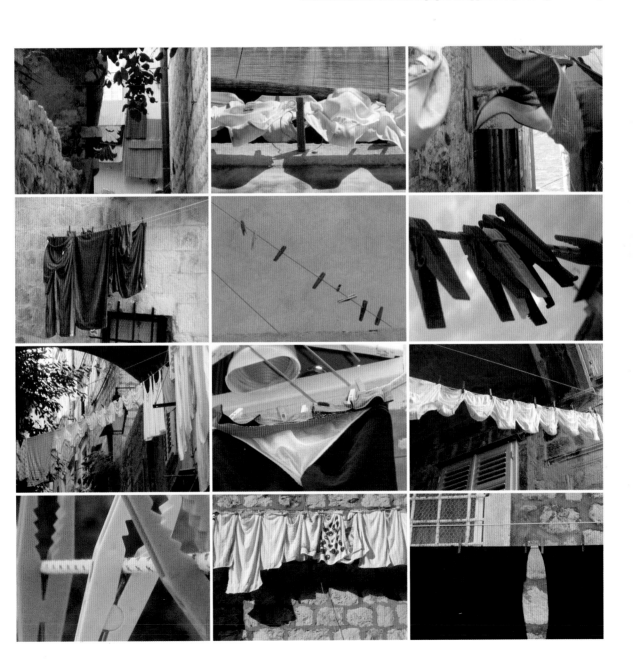

THE ART OF COMPOSITION

**STALKING
THE MUNDANE**

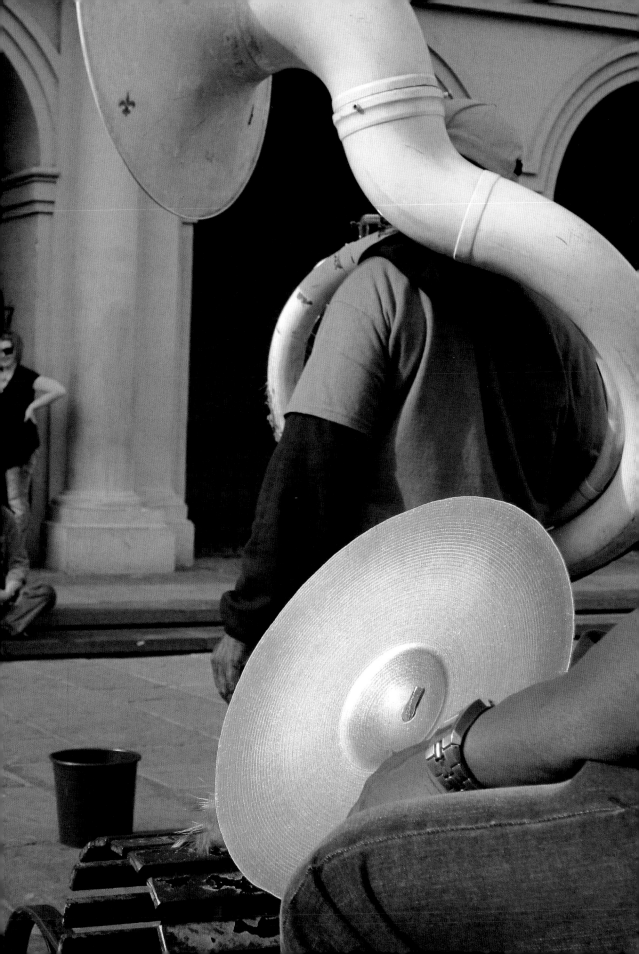

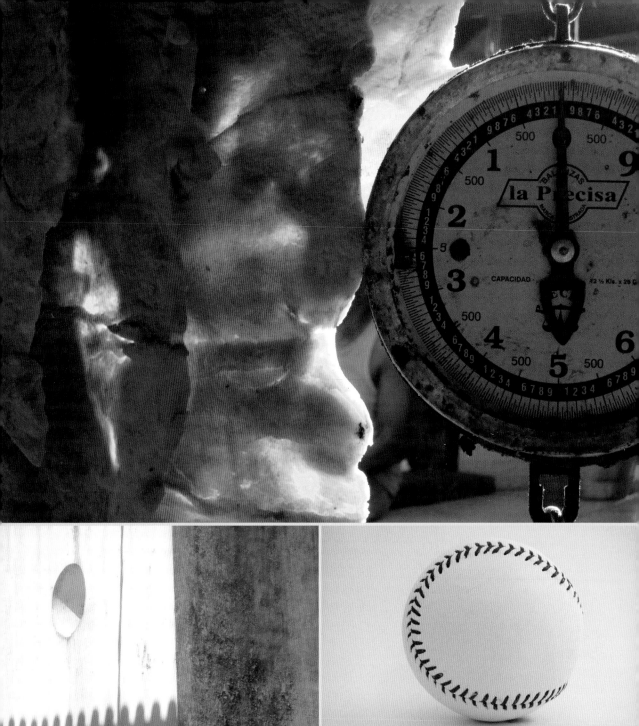
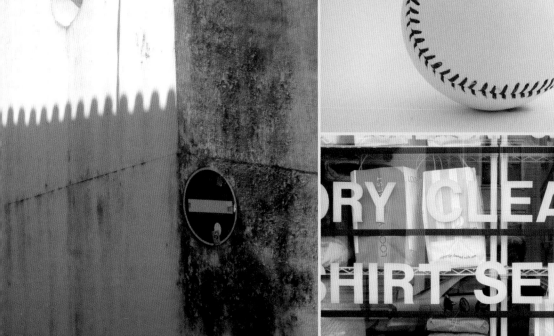

55

previous
NEW ORLEANS

left top
CARTAGENA

far left bottom
EVORA

left bottom
SAN FRANCISCO
SAN FRANCISCO

"COMPOSITION" IS AN all-purpose word of creatives across fields—familiar equally to musicians, chefs, painters, photographers, civic designers—and it is the driving force behind this book.

Composition is what "having an eye" is—and the photos in this book show how my eye composes things, which, at this point, is intuitive for me. I believe anyone can develop an eye for composition, and I believe everyone so inclined should give it a go. It's quite simple:

Start with something you delight in.

In my case, this means farmers' markets.

This translucent slab of hanging fat in a Colombian farmers' market, with the morning sunlight coming through, becomes interesting or intriguing when juxtaposed with the mechanical scale. On its own, it's simply an unctuous side of lard. The contrast of a hard-edged mechanical device and the silken fat, however, sets up a visual comparison that makes me want to keep looking.

It's a very different type of composition than this crisp, bold visual statement, taken from a local dry cleaner's window. In this case, color and geometry draw us in.

I often stalk mundane objects. Why? The pleasure of discovering beauty and power in unexpected places. I typically take multiple shots of my subjects, moving to find different angles and depths, in order to get to the right image.

What is my eye seeking in these shots? Beauty is not the point, but beauty is the force that draws my eye to the image and subject matter. Will you find the same things beautiful that I do? Sometimes yes, sometimes no. In both cases, stop and ask yourself why: Why do you engage—or not—with an image?

The ancient Greeks believed that beauty resulted from three elements: proportion, symmetry, and harmony. And I am old-school enough to believe that they had it about right, and that these elements are all at play in my images and apply equally to underwear pinned on lines in Croatia, shiny tubas in New Orleans, and gridded parking lots in San Francisco.

My personal sense of composition, my eye, is a by-product of art training and, especially, from making pottery for ten years. During this time, I felt—and learned— nuances in shape, texture, and material from extreme repetition of the same form. As a result, I am more object-focused in composition.

Very simple, minimal objects like a baseball or a cappuccino can be made into compositions of merit simply by viewing them from a unique perspective. More complex arrangements, like this hosiery image from a flea market in Catania, Sicily, offer a different challenge—one finding balance in and making sense of a potpourri of dots, angles, legs, reflection, color, plastic, glass, wood, tape, concrete, steel, verticals, horizontals, and soft and hard surfaces.

Composition comes naturally to us all, even those who don't recognize it as a habit or who have no art training. Putting things in order is in our DNA. Think of the

right top
MALLORCA

far right top
CANTANIA
COPENHAGEN

right bottom
AMSTERDAM

56

simple routines of each day—observe how you arrange your desk or dining tables or garments.

This image taken from a café table in Copenhagen is a good example. An older man had laid out a very sophisticated composition of drinks and smoking gear to start off his day (and give order to his life).

A professional stylist would be challenged to find a more pleasing arrangement for these elements.

Every object or space or environment offers up composition opportunities, and each has a narrative behind it. The page you are looking at is a composition; so is the next website you pull up or the next dashboard you see. Some are lyrical, others humorous, some a play on materials and light, as with these beer bottles I saw in Holland. The act of simply recognizing and appreciating these narratives has value.

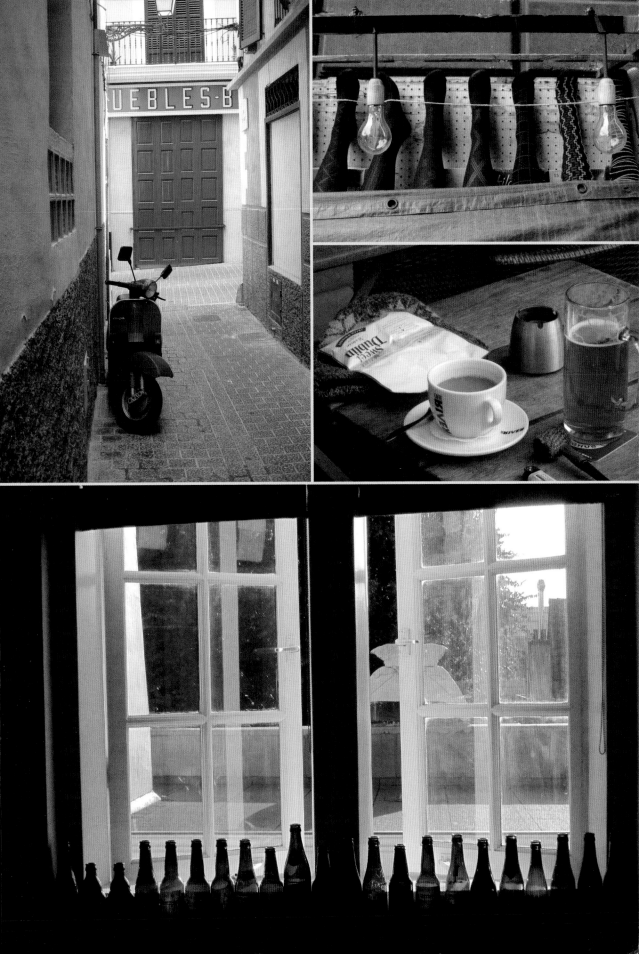

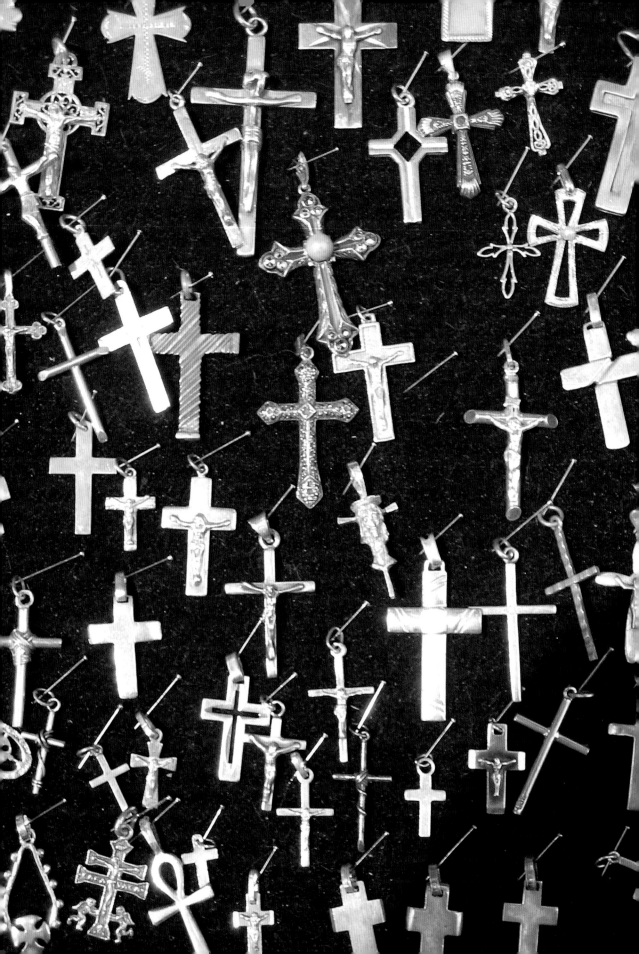

DECORATION

previous
MONTEVIDEO

left
LUCCA
BOLOGNA
SIENA

right
ROME

60

We adorn the world with decoration—both to beautify and to honor.

Thus, by definition, decoration lives largely on the surface, free to wander and play and amuse and laud. It can alternately be whimsical, serious, symbolic, referential, silly, abstract, complicated, or simple.

Because decoration takes time and money and (ostensibly) does not have utility, there has been a predictable loss of decoration in the modern world. Ardent modernists dismiss decoration because it lacks perceived function.

Yet this raises fascinating questions for us to consider: Isn't color—or any visual surface treatment—decoration? It can't be avoided. And if it makes you look more precisely at form, or makes you think, or pleases the eye at the same time, doesn't that serve a function? The most successful decoration feels essential; it wasn't added to mask or hide—that is, to manipulate us.

Construction sites offer a raw elegance and have long held my interest—often beyond the finished, polished structures they become. An example in Buenos Aires stands out for the quirky magenta construction tape squiggles that create a playful feel. The squiggles become a random element, perfectly contrasting with the regular, rectangular boxes. The scene is further

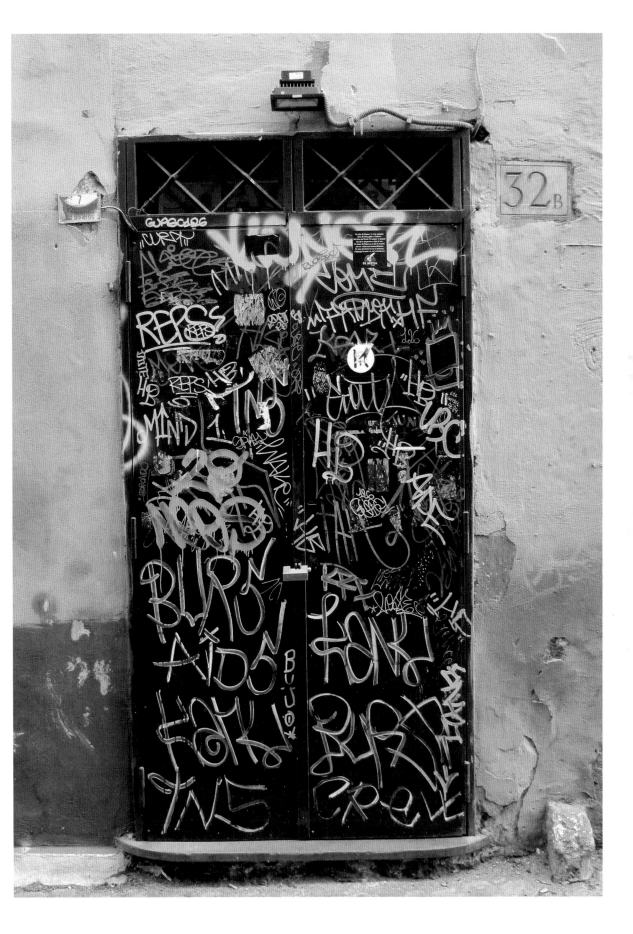

The most successful decoration feels essential.

left
BUENOS AIRES
NEW ORLEANS

right
SAN FRANCISCO
NEW ORLEANS

next
PANAMA CITY
VENICE

enhanced by construction workers in hard hats, unaware of their role in this playful composition.

Decoration reaches a zenith in religious buildings, which may be another reason why it is snubbed in modern design circles. Classic examples include the Islam-inspired Alhambra in Granada, the Temple of the Emerald Buddha in Bangkok, and Antoni Gaudí's work in Barcelona. But examples of decoration can be appreciated in almost any urban environment. The best graffiti or everyday fonts of apartment numbers have noteworthy appeal. And some cities—New Orleans comes to mind—are defined by a decorative sensibility at every turn.

In my own neighborhood in San Francisco, these curvy appointments and embellished columns tell a story of a sweet reverence for the traditional and historical. They also show a love and care and desire to make the building and neighborhood special. That alone gives them great value, and they are a nice counterpoint to the more spare modern buildings in the neighborhood. In this case, decoration contributes to the diversity of the neighborhood, adding texture that creates personality, and makes the community feel more human and friendly.

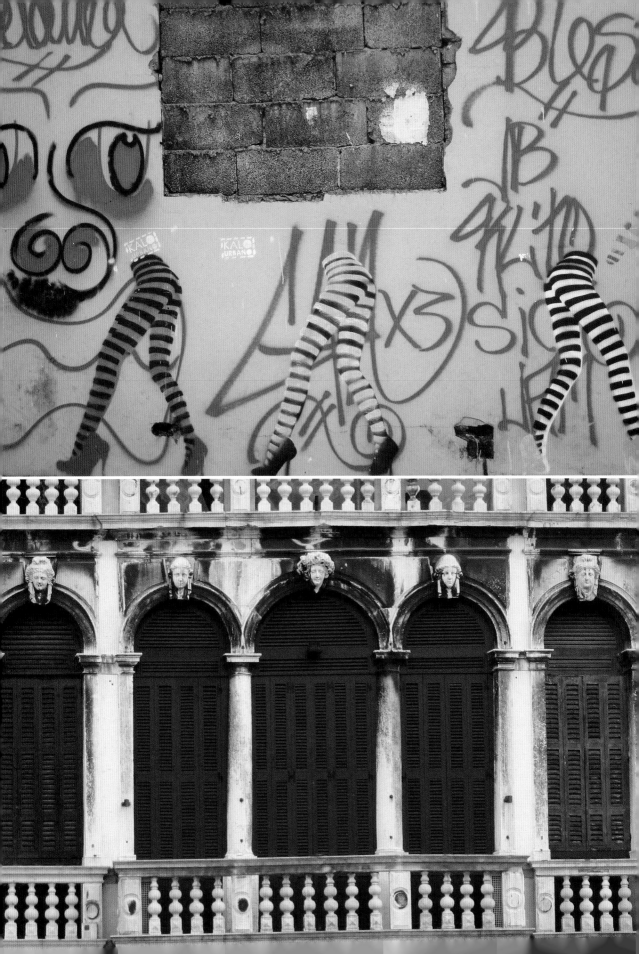

HOUSE NUMBERS
CHARLESTON, SOUTH CAROLINA

Charleston is one of the best American cities to stroll around and see the texture of centuries of architecture and design. It was one of the few cities bypassed by the twentieth-century onslaught of the automobile. Nothing about it is modern and standardized. The mix of stone arches, wooden balustrades, red bricks, marble, wrought iron, and clapboard reflects various architectural styles. It also has an amazing array of house numbers. With a modest population of just over 120,000, it nonetheless has a greater range of styles and materials used on house numbers than in almost any large city I have visited.

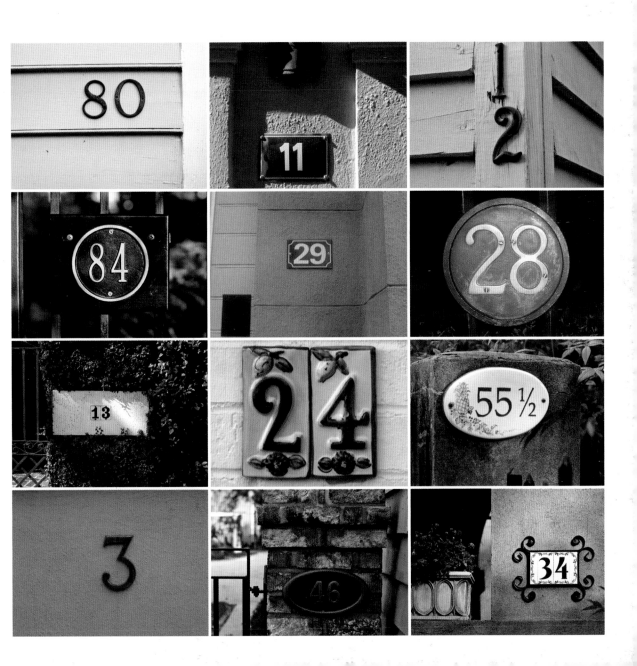

FORM

"It's about just one thing, you know: 'the majesty of form.'" —Michael Cardew

As a young apprentice throwing pots for the legendary British potter Michael Cardew, I naively thought I was just making some bowls. But a large part of my training in Cardew's workshop invited an understanding of form, through both the body and the eye.

However, the concept of form did not really register with me at the time. I confused the notion of form with shape. Form is much more complex; it's a big subject and a tricky word to define. It is at the heart of this entire practice of seeing and is the measure of value in art, life, everything.

Form hovers somewhere at the intersection of function and context, and it exists in all works of design, even if they are not visual. Music has as much form as a building, as does literature and movement and smell. When we say a person has good form, we may be describing a look or walk—or we could be describing a manner of speaking or even assorted behaviors that add up to an overall effect.

Form is about essence, which is why it embodies a kind of majesty; it is often easier to see in basic, utilitarian objects. Look around your bathroom or kitchen; consider the wooden spoon, bottle opener, bobby pins,

needles, combs; take a careful look at a bicycle wheel or table leg or shallot left to dry on a kitchen window ledge. If you can recognize form in the everyday things, you can recognize it in more complex objects or spaces.

Ideal form is not worth trying to define with words; we can see and feel it so readily in the natural world. The nautilus shell is used to equate beauty and ideal form, and reflects the harmonious mathematical proportions, incorporating the golden mean.

Yet in our built world, ideal form is elusive and hard to define, but a truism is that good form offers values—purity, honesty, frankness—that transcend commercial metrics.

Ask designers to identify and describe good form, and many will point to an iconic modern chair—usually by Ray and Charles Eames—or a Mies van der Rohe building, or a Shaker box, or a vintage Porsche. Ask them to do the same for a city or street, and they will usually pause. It is much harder to see and appreciate form in dynamic systems.

In order to stretch our minds around the role of form in everyday life, I'd offer that any public space or structure elegantly serving community needs is a good place to start. The Campo in Siena, Italy, is a classic example. Millennium Park in Chicago, which opened in 2004, reestablished Chicago as an international travel destination and center for art and architecture. Millennium Park succeeds because it provides an inspirational urban space for all segments of society. Its form has had a huge impact on the city. Along the same lines we have the High Line in New York, the Paris Metro, and Golden Gate Park in San Francisco. All great cities offer moments of dynamic form—well-considered streets inviting use by bikes and pedestrians, streetcars, trains, and buses where seating makes sense—that shape and define their communities. They are just not so readily discussed as form; yet their inherent utility—the

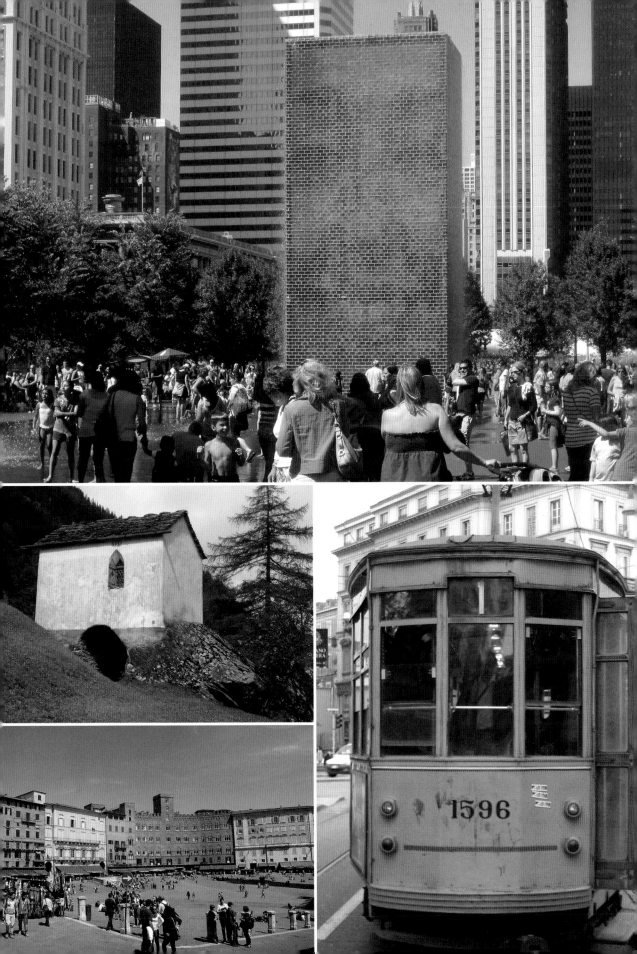

Music has as much form as a building, as does literature and movement and smell.

left
NEW YORK
BRA

right
BANEDUP ISLAND

next
BOLOGNA
PORTLAND

70

fact that they serve the public so well—deserves recognition.

I live on a street where a vintage cable car line trundles and creaks by each day; the cable car offers an experience of transit and environment that defines great form. While its utility has morphed from public transit to tourist thrill, it retains good form regardless of purpose. Both adults and children are exhilarated to ride a cable car, clutching iron rails, sliding along varnished benches, listening to the thrum of the cable tug the car over the steep hills. This system's Old World character enhances our modern world, an example of authentic good form.

———————————

———————————

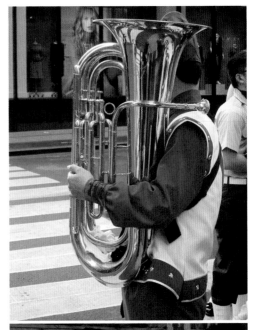

STONE WALLS
MARTHA'S VINEYARD, MASSACHUSETTS

Riding a bike around Martha's Vineyard allowed me to study the stone walls that make up a signature detail of the island. A lot of thought went into the selection and placement of the stones, resulting in some graceful balances of art and engineering. The spaces between the rocks allowed light to pass through, reminding me of the spaces between notes in music. The right walls—and musical compositions—will have counterpoint, rhythm, melody, and balance.

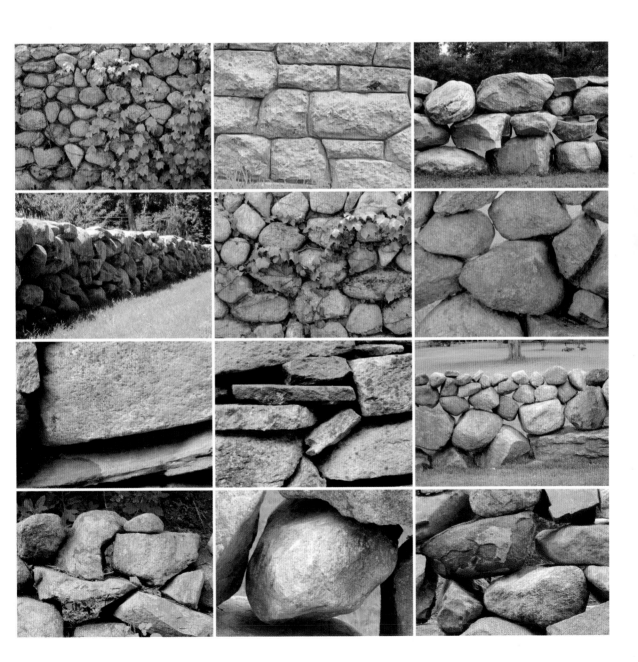

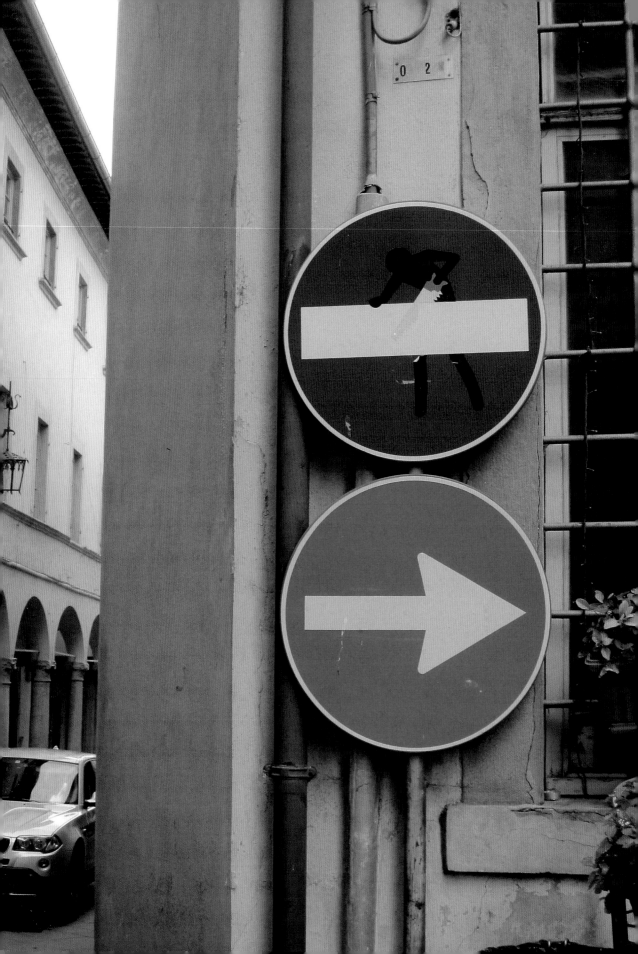

HU
MOR

previous
POPPI

right top
BONNEVILLE SALT FLATS

far right top
MEXICO CITY

right bottom
BOLOGNA

76

I was walking through one of the typical rural towns in Tuscany and came upon a road sign that some artist had modified into a witty graphic statement.

It was subtle and required a double take to see and appreciate. Two things struck me about it beyond its cleverness. First, that the city was comfortable leaving this road sign in place—that is, not restoring it to its original, correct form. Second, that humor and levity, while essential to our mental well-being, are rarely designed into our man-made world.

Later I learned that the road-sign piece was done by French artist Clet Abraham, who has been performing these interventions around Europe, much to the displeasure of many city councils. Abraham does intend a serious message, asking us to think twice about the associated instruction, and he believes that much public signage is not done with sensitivity to the urban landscape.

Examples of humor in any form of functional design in the public space are rare. This is only logical, as when it comes to the design of our cities and public spaces we must first concern ourselves with issues like crime, safe streets, affordable housing, and clean water—things that are no joking matter. We sometimes soften the urban environment and make it friendlier, lining freeways or streets with trees, creating parks and public spaces that give us relief from the hard/concrete/industrial character of the cities, but we stop short of injecting humor. Humor almost always pokes fun at some constituency, so it is by definition not politically correct and unlikely to get civic support. So if we want to find humor, we have to create it—as artists do—or simply see it ourselves.

Artists have been injecting humor into our public world for centuries; this Fountain of Neptune in Bologna, with sea nymphs with lactating breasts, was commissioned by the local cardinal and dates back to the sixteenth century. And whimsical works with animals and mythical beasts continue to amuse us, like Jeff Koons's *Puppy* in Bilbao, or Paola Pivi's donkey in a boat in Venice, or painted cows seen on the street, or dangling rubber lobsters seen in a restaurant kitchen.

Why is it that examples like this are common in Europe and not so common in the United States? We do take ourselves unusually seriously here, so seriously in fact that we would take one of the most picturesque locations and one of the most valuable pieces of real estate in the San Francisco Bay Area, Alcatraz Island, to showcase a defunct prison rather than, say, a park. The humor—or at least the irony—is that it is now a highly successful tourist destination.

The fact that we take ourselves so seriously is comical in itself. Someone patriotic embellished a trashcan with an American flag as if to brand America with its waste. Supposedly enjoyable and comforting beach fire pits are branded with graphics loud enough to warn off any intruder.

But the easiest way to find humor in the landscape is to see it and create it yourself. A doorbell can be read and composed into a comical face, a chunk of concrete into an animated character, a mannequin into a public execution. Seeing children being led through the neighborhood like a chain gang or something as simple

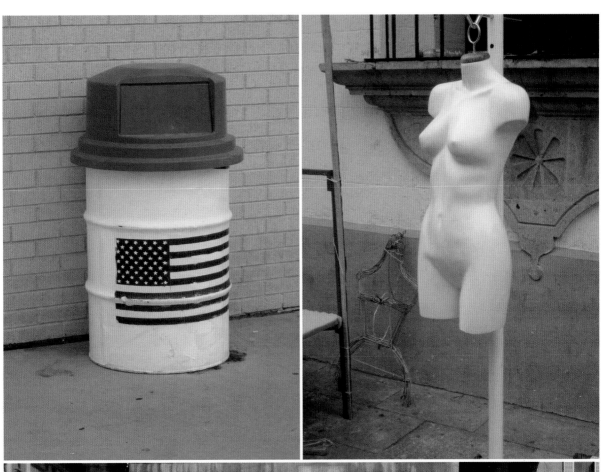

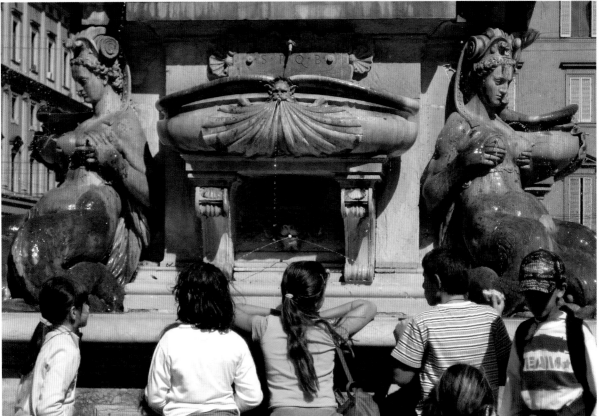

Humor, like beauty, is in the
eye of the beholder.

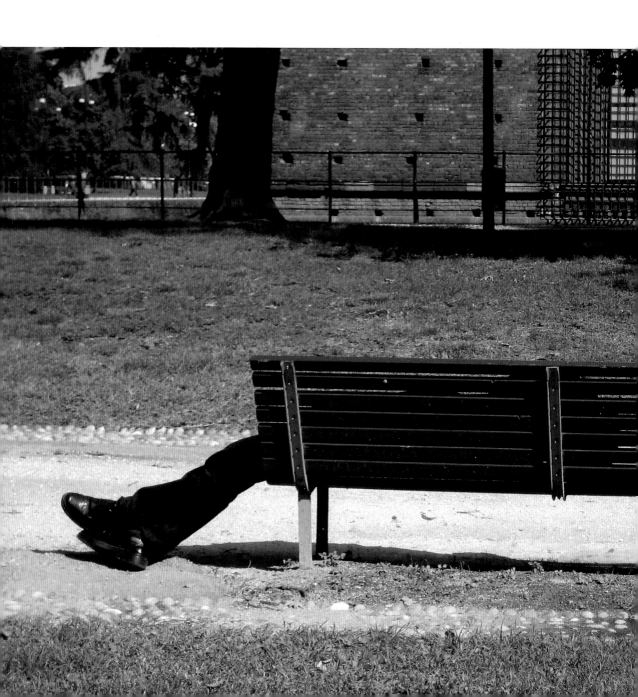

79

left
MILAN

right
CORONA DEL MAR
NEW YORK
VENICE

next
GREENSBORO
SAN FRANCISCO

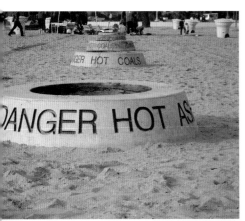

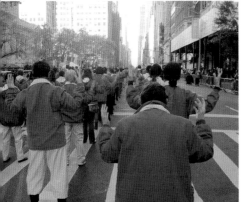

as two contrasting pieces of footwear. Seeing how we improvise to use public seating in a manner other than how it was designed to be used is comical. And finding these juxtapositions helps soften the edge of the urban landscape.

Humor, like beauty, is in the eye of the beholder and is almost everywhere—if we choose to look for it.

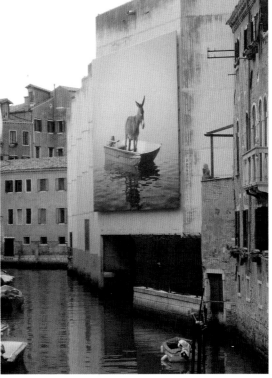

DOORBELLS
VENICE, ITALY

Doorbells are not on the list of tourist sights to be seen in this historic city, but they are a unique signature detail that keeps Venice Venice as much as the gondolas do. Some appear as funny faces, other as studies in materials and surfaces. They are a great example of local detail that gets you to look at each residence carefully and encourages a slower and more curious walk through town.

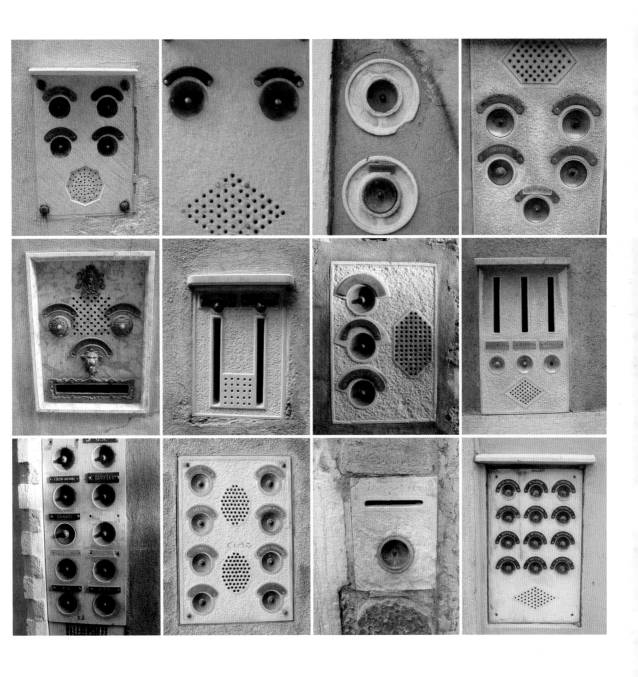

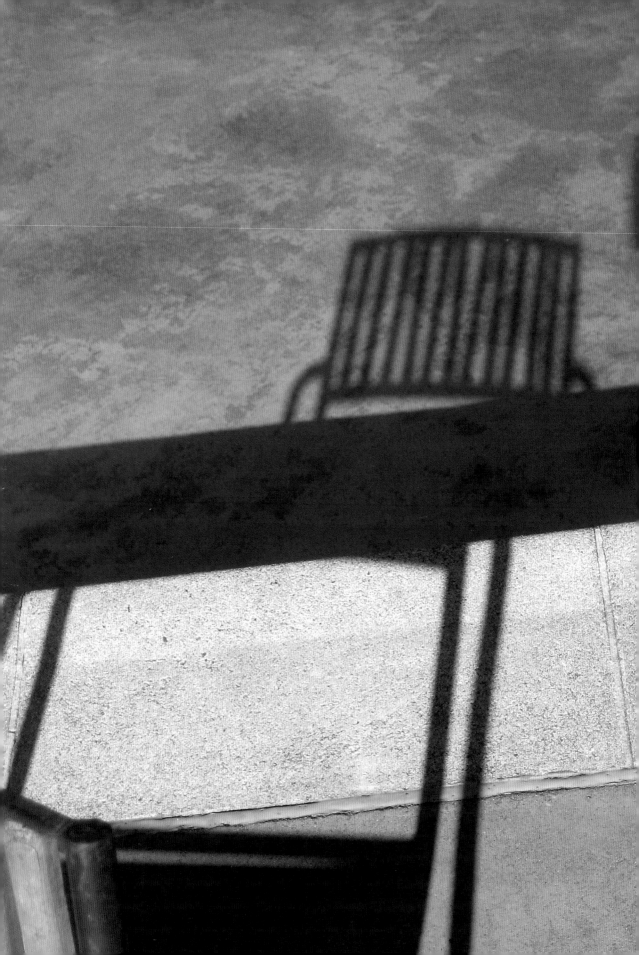

LIGHT & SHADOW

previous
GLEN ELLEN

right
PARMA

far right
MALLORCA
ROME

―――――――――
―――――――――

I recall a provocative example of the visual power of light.

I was seated in a modest café in Mallorca, Spain, finishing a leisurely lunch with friends and enjoying the seaside quiet. Then a bus arrived and disgorged a swarm of boisterous tourists, thoroughly dismantling the mood both visually and acoustically. We sat waiting impatiently for the check, eager to get away from the invasion.

Suddenly the sun appeared from behind the clouds, blanketing the café and patrons in vivid dots of light, a pattern created by the perforated awning. The atmosphere underwent a complete transformation. Bodies retreated into the background, like deer camouflaged in a forest. We departed calm and amused, not irritated. It reminded me how light and its patterns have a profound effect on any environment. Lighting can change one's mood from irritation to tranquility in a second.

This power has not been lost on great designers and architects. Modern architects like Louis Kahn, Luis Barragán, and Rudolf Schindler integrated natural light into their structures in ways that recognize and celebrate its very nature. Kahn's Kimbell Art Museum in Fort Worth might be the quintessential example because of the way in which shadow and light get equal

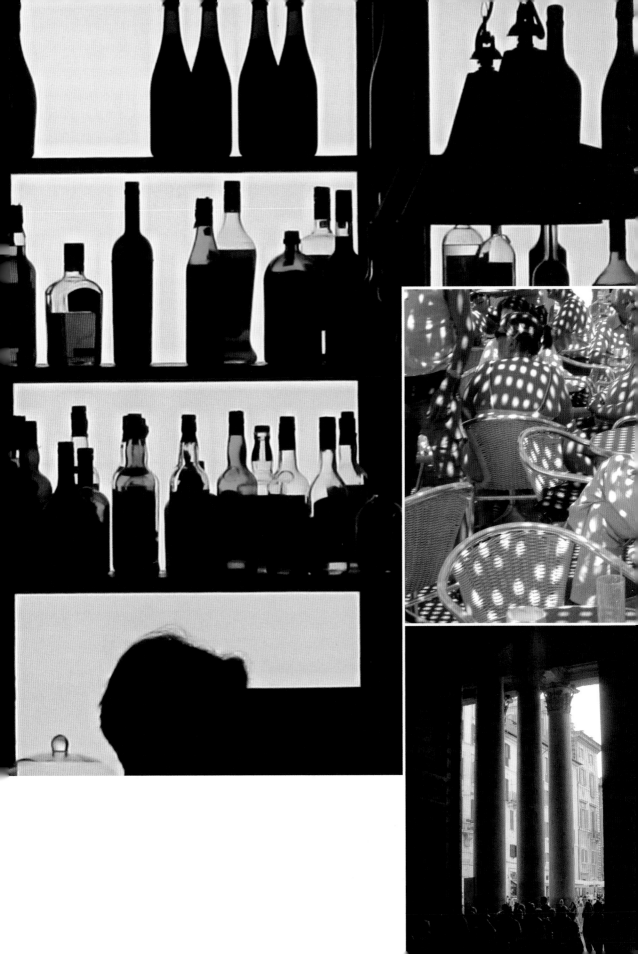

left
MEXICO CITY
FORT WORTH

right
LOS ANGELES
VENICE

next
BOLOGNA
VENICE

86

play and, in fact, define each other. I stumbled into a James Turrell show at the Whitney Museum more than thirty years ago, and I can still summon up images from this installation.

Chris Burden's *Urban Light*, an assemblage of two hundred vintage street lamps repurposed into a provocative installation, is apparently the most photographed public object in Los Angeles. It serves as an example of how an artist helps us to see light in a fresh and original manner while also encouraging us to appreciate both light and lighting for their potential.

Light today comes at us often through the back door—backlit signs, phones, and laptops. And LCDs are creating a sea change in interior lighting. Who knows where this will lead us in our awareness and appreciation of light? But it should inspire us to be that much more curious about light in its purest forms.

———————————
———————————

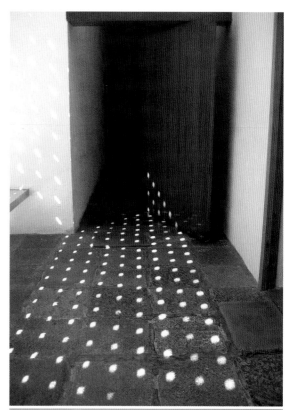

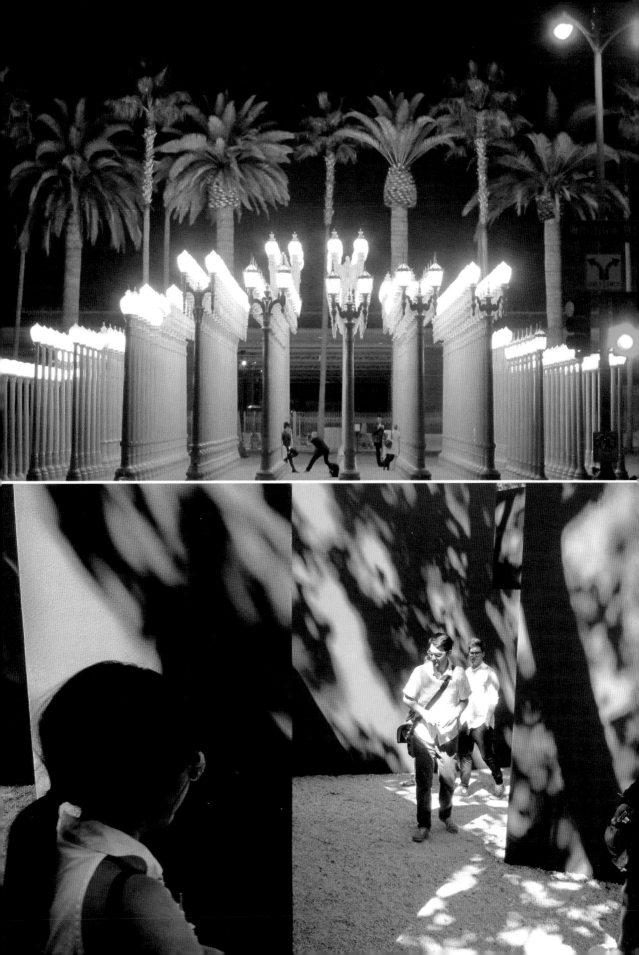

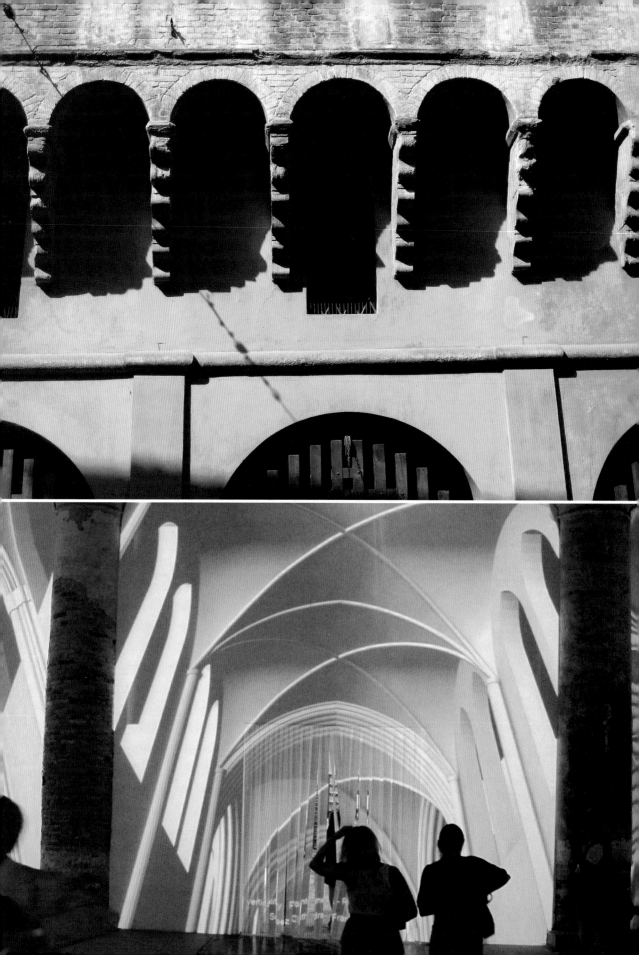

CACTI
OAXACA, MEXICO

I am not much of a nature photographer. However, when I came across cacti in Oaxaca exuding architectural character, the crisp, strong lines captivated my eye. It felt like an improvisational study in form and lighting and texture and structure. Does the man-made landscape help us see nature with fresh eyes? Of course.

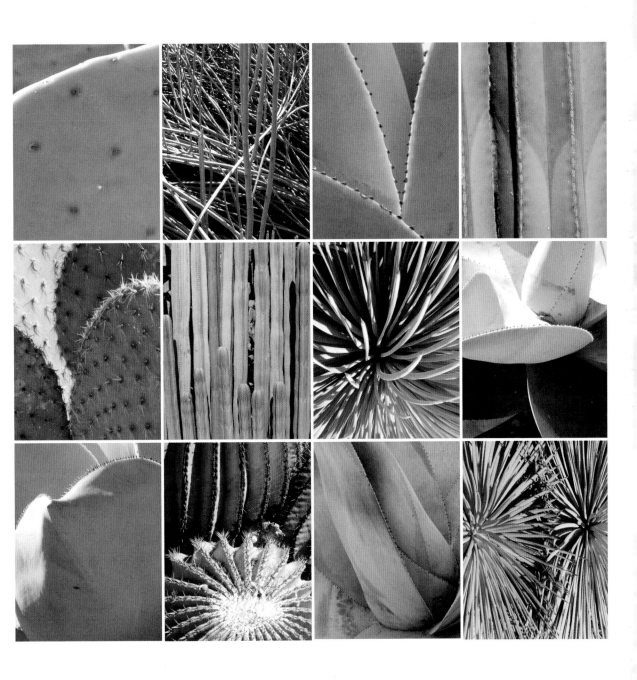

WHERE TO SEE STUFF

**FACTORY FLOORS,
BUMPY STREETS &
FOOD CARTS**

ONE TERRIFIC THING about seeing for yourself: You don't have to go far to do it. The obvious place to start looking for stuff is right under your nose. There is probably an interesting composition to be found around you wherever you are reading this book. You can make an interesting composition out of almost anything if you play around a little and see it from a fresh perspective.

But the reality is we often find inspiration, and take more time to look at things, when we step outside our daily routines. Travel opens our eyes, and the inspiration for this book began as I traveled abroad. It led me to ponder why I was so alert to details in Italy yet so indifferent to them back home in San Francisco. I began an exercise of more mindful observation of my immediate surroundings. We travel for a number of reasons; we come back, as they say, with stories to tell but also with a fresh perspective on where we live.

MARKETS, PORTS, FACTORIES, STUDIOS

My favorite haunts and my most reliable sources for inspiration are primarily urban. Within that context, I seek out places where we are not being directed to what to see, or being manipulated and told what to buy. (This may strike many readers as surprising, given my own work in creating marketplaces for selling designed goods and products for our lives.) Many of my images come from workplaces: commercial kitchens, toolsheds, artists' and designers' studios, ports, ranches, and factory floors. These are all places where things are produced rather than sold. The human love and need for making things has been a personal inspiration to me, dating back to childhood and then ten years producing ceramics.

Images taken from a road trip through Maine one summer help illustrate my point. If you view Maine from a car traveling on main roads in summer, it feels like one big tag sale and discount shopping mall. The signage itself is more curious and amusing than the products being sold. But take a detour and head toward working harbors and docks, and you'll soon see stacked, graying lobster crates, red-and-white tattered buoys, tangled fishing gear, sea-battered boats, and other unaffected examples of human engineering and purpose. Maine corners the market on quaint small towns, and we find predictable artwork being sold along Main Streets, items made as mementos to feed a tourist trade. So get into the abundant nearby artists' studios and see this: The way brushes and tools are arranged gives us as much insight into the artist's thinking as his or her artwork. What we do unconsciously is more revealing than what we do consciously. In this case the human need for order, to get work done, to fuel a need to make, is both honest and elegant.

Factory floors often make for studies in materials, patterns, and shapes. Again, how something is made—the series of gestures and materials—is often more interesting to me than the final object or good with its intended use. I equate this with how

right top
NAPLES

right bottom
DEER ISLAND

far right bottom
VINEYARD HAVEN

94

many of us prefer dining at a restaurant counter, watching the line cook move through a specific choreography with ingredients, tools, and flame, rather than sitting at a table awaiting the final dish. I take every opportunity to visit artists and designers in their studios and chefs in their kitchens—just to see stuff they have around, in what form, and how it is arranged.

Live and spontaneous markets and shops are particularly compelling for many of us—it's no wonder we see so much activity in so many American cities these days: street vendors, food trucks, local farmers, flea and fish markets, cafés, roadside stands. Places run by people who know and love what they sell. (As opposed to chain stores managed by marketing managers who prioritize products on the shelves based first on profit margins and staffed by employees clocking time.) In farmers' markets, owners stack and arrange their goods without the need to shroud it in commercial packaging. We see and feel integrity and simplicity at work, and a direct hand involved. As humans, we are traders and barterers, and this direct encounter with makers reminds us of this honest social need.

Farmers' markets have been growing at a faster pace than malls in the last decade, in blue and red states alike. We all love them. Perhaps this is because the stacked fruit and vegetables remind us that we are, and always have been, gatherers. Or perhaps the patterns and repetition of these foodstuffs are lodged somewhere in our deep subconscious as substances of survival. We equate them with all that is good: contentment, serenity, and feeling our place in the world.

CITIES

Most of the photos in this book are taken from the streets of cities. So, why is that? Cities are the best places for the obvious reason that they have a lot more streets and sidewalks, but they also have greater density of everything: people, buildings, history, products, stores, signs, and all the other details that combine to make up texture.

They are where most of us spend most of our time, in ever-increasing numbers. (The year 2012 marked the first time in human history that more people lived in cities than not.) More is at stake for us in our cities: They simply mean more to more people than other places. They are the repository and centers of our culture. Many cities have been under siege from the forces of shortsighted modern commercial development, and in particular the automobile, over the last fifty years, so they deserve a special focus today. The greater awareness we have toward our cities, the more likely we will be to preserve their assets.

Almost any town or city will have an abundance of subjects for visual study, and there are photos from more than a hundred cities or towns in this book. I've made examples of three of my favorite cities, each with unique history and circumstances

that made them special: Charleston, South Carolina; Cartagena, Colombia; and Amsterdam, Netherlands. As diverse as these cities are, they share one common trait: They are extremely pedestrian friendly, that is, walkable. And none of these examples came to be pedestrian friendly by chance, but rather by unique forces that allowed them to preserve their identity. In these cases the forces were, respectively, a mayor, an international organization, and a public protest.

Charleston, South Carolina

The more walkable U.S. cities, such as New York, Chicago, and San Francisco, are a lot more conducive to seeing than those cities that were designed around the car, such as Houston, Atlanta, and Los Angeles, where walking is not given much of a chance. And one smaller U.S. city holds its own against the bigger metropolises: Charleston, South Carolina. Walk this city (with a modest population of 120,000), and you will find more diversity in architecture and cultural history and texture than you will in many much larger cities. How did this happen? Simple. The roads were not widened to make it easy for cars to speed through, parking lots did not take up precious public space, and shortsighted developers were prevented from replacing older, historic buildings. The shortsighted commercial interests have been kept at bay by the visionary mayor, Joe Riley, an eight-term politician who has battled to keep the city safe and sane for residents, not cars, for four decades.

And all across America the same phenomenon can be seen: a visionary mayor taking a stand for public spaces and residents over the need to move cars in and out of the city and thoughtless development. It has been through the force of their will and political power that we now have world-class destinations such as Millennium Park in Chicago (Mayor Richard Daley); and a rehabilitated Times Square, High Line, and neighborhood amenities such as bike lanes in New York (Mayor Michael Bloomberg). An outstanding example of this in San Francisco was Mayor Art Agnos's decision to block the rebuilding of the Embarcadero Freeway following the Loma Prieta earthquake in 1989. The east-facing waterfront has become one of the most valuable amenities in the city, thanks to a mayor with vision and conviction. (He lost the subsequent reelection, at least partially for taking this stand.) In the pre-auto era in the United States we had many examples of enlightened civic planning, Central Park and Golden Gate Park being great examples. But such needs and vision were subordinated to the automobile and its requirements for most of the twentieth century.

right top
CARTAGENA

far right top
AMSTERDAM

right bottom
AMSTERDAM

98

Cartagena, Colombia

Cartagena is teeming with color and texture and diversity, and is a feast for the visual senses. Dense, saturated colors are everywhere—taking your eye and curiosity to the most common objects: doors, hardware, carts' wheels, fruit, hats, flip-flops. There is virtually no commercial signage. Roads in the historic city center have not been widened. Vendors in carts rule the streets. The public spaces are almost always occupied by people enjoying themselves. Cartagena did not become this way by chance. It became a designated World Heritage Site by the United Nations Educational, Scientific, and Cultural Organization (UNESCO), one of the few governing bodies that has been effective at preventing the wrong kind of development.

UNESCO, whose aim is "to contribute to the building of peace, the eradication of poverty, sustainable development, and intercultural dialogue through education, the sciences, culture, communication, and information," is not first thought of as having its positive force on our cities; it is better known for helping to protect places like the Grand Canyon and Chartres Cathedral from commercial development. But I have encountered UNESCO at work to help preserve older historic cities as diverse as Havana, Cuba, and Santa Fe, New Mexico. It has almost eight hundred places under its watch, and within all of them there is a lot to look at.

Amsterdam, Netherlands

Amsterdam sets the gold standard for walking streets and seeing stuff. The canals, narrow streets, flat topography, ubiquitous bicycles, and the human scale of the city make it unique. We take its character for granted, but we are lucky: It might not have ended up this way. The very fabric of the city was almost destroyed in the late '70s when city fathers planned to "Americanize" it and construct overhead roadways across the city connecting the train station and city center to the outskirts. Hippies, anarchists, and entrenched residents blocked it. It was a close call—only one vote of sixteen staved off the development. Credit public protest for making Amsterdam what it is today.

The Dutch are an extremely visual culture. They are one of the few European cultures that holds its own against the Italians for thought leadership in contemporary modern design and visual curiosity. Could it be that because everyone walks or bikes and moves around at a slower pace that they simply see more and are more aware and appreciative of what they see? They are also one of the most individualistic and witty visual cultures. You won't find rubber lobsters hanging in an Italian kitchen.

LESSONS FROM ITALY:
GOOD SIDEWALKS AND GOOD FOOD ARE
THE CORNERSTONES OF CIVILIZATION

Italians don't seem to be able to keep a government in place for more than a year. Their economy seems to be in a perpetual tailspin. The power and influence of the Catholic Church seems onerous, silly, and anachronistic to many of us. Yet the Italians have other, enviable cultural practices, guaranteed by political decree: Espressos cannot cost more than €0.66 (90 cents); bread and cheese prices are fixed at affordable rates; farmers' markets are mandated in every community; fresh, clean water is accessible and free everywhere; and private cars are largely banned from city centers, ensuring walkable cities. Thus Italy remains my favorite travel destination, and the best place to see and appreciate the details of our man-made world.

How did Italy get this way? First, the Italians have preserved the fabric of their artisanal past while adjusting to the modern industrial world. Unique family craft businesses are cherished and nurtured. Italians' handmade goods are world renowned; their craftspeople set the bar for silks, shoes, chairs, hats, lamps, bags, ceramics, glass, wines, oils, and belts—and the list could go on and on. They have a national confederation of small businesses with a cultural bias toward individuality and elegance. Furthermore, the "eye" and love for utility has allowed them also to define modern design for the world. While the United States and many other modern cultures spent most of the twentieth century pioneering the path called "bigger and cheaper," Italy has continued to make many things better, modern furnishings for example. They have a cultural disposition toward beauty—as a result Italy is very easy on the eyes.

More than any other modern country I know, Italy managed to keep the rights of cars subordinated to those of pedestrians during the twentieth century. Public transportation like trains, trolleys, and buses is used to move people about the city, often more so than cars. Most of their cities neither widened streets to encourage cars to cut through communities nor did they pepper their downtowns with street-level parking lots. It may be that simple. As a result, there are more piazzas, walkable streets, sidewalk cafés, parks, and other relaxing and elegant public spaces.

There is an irony here. Italians love cars and driving, perhaps more so than in the United States. Per capita car ownership is much higher than anywhere else in Europe, and rivals America's. Brands like Ferrari, Maserati, Alfa Romeo, and Lamborghini— among the most coveted designs and engines on the planet—are legendary. But cars don't shape and drive civic life. People do. And they don't protest the high cost of gas at the pump (around €1.80/liter, or $10 a gallon), at least partially because they know

that the taxes are used to help subsidize their development of mass transit. Italian trains can be as fast and sexy as their cars.

Italy has also developed and designed cars specifically for the angles and dimensions of the built environment. Rather than widening roads and destroying pedestrian life, they scale cars to fit their current reality. The Fiat 500 was the first "smart car," able to pack in a family and navigate narrow, twisting roads common even in larger cities. It has taken fifty years for the rest of Europe to wake up to this. On a recent trip to Rome, I noticed how cars, pedestrians, architecture, and sidewalk cafés all reside companionably in the same zone. Here is the simple lesson: Just limit the size and number of private cars in city centers.

It is worth pondering how the descendants of the Romans—a society known as fantastic road designers and builders—managed not to be swallowed up by automobiles in the twentieth century (unlike most other modern countries). Milan, a noted leader in modern civic and other design, has some of the bumpiest roads of any modern city. But this is intentional, and operates on two levels: The rough ride preserves the historic character of the city and keeps cars from racing through downtown.

The Milanese aren't bothered by the bumps—why would they coat all their beautiful stone roads with asphalt? It might be functionally sensible, but they have a bigger picture in mind, one that extends beyond speed, time, and direction and other auto-transit obsessions common in the United States. Roads in Italy are an integrated part of the larger cultural experience. In many ways, this choice can be seen as an extension of their traditional diet, one embracing seasonal foods with vigor, centered on the habitual pasta and tomatoes and olive oil. Good sidewalks and good food may be the cornerstones of civilization.

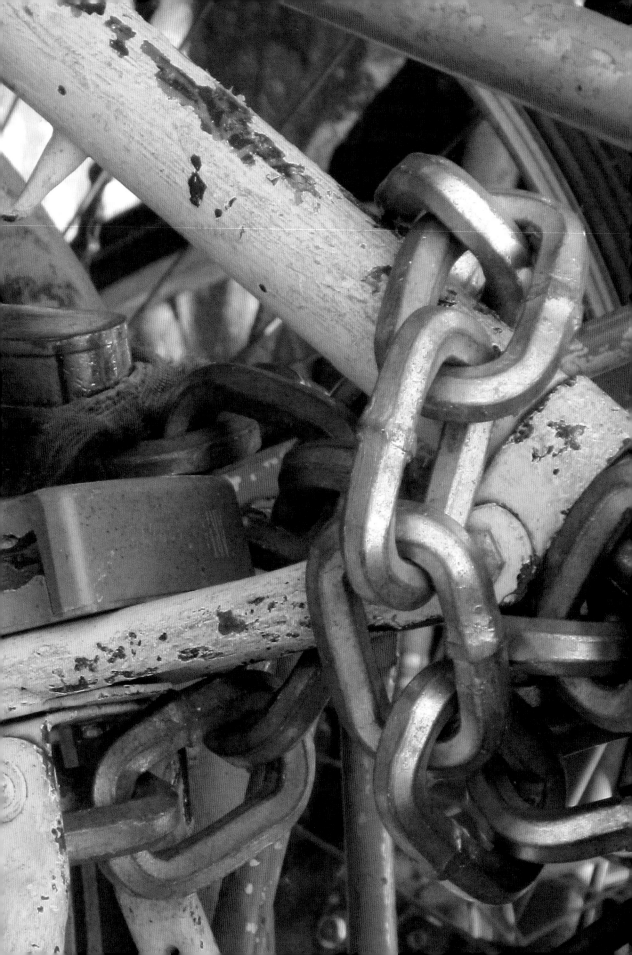

MATERIALITY

previous
AMSTERDAM

right
SAUSALITO
AMSTERDAM

106

Contact with natural materials delivers a basic human pleasure; it connects us with our primal roots.

As children, we played in sandboxes and mud puddles, made things out of clay, swam in the ocean, walked in the grass, climbed trees, ate ice cream. Our appreciation of natural materials does not wane with age; later in life it comes across as a preference for leather pants, cotton shirts, hardwood floors, and marble and granite counters.

I have an obsession with urinals and toilets. I don't think it's because I'm kinky; rather, it's because I was a potter for years and worked with porcelain. I have an obsession with material itself for its endurance and permanence. I start most days drinking my coffee from a twelfth-century porcelain tea bowl that reminds me of how formidable this man-made material is.

Yet pure, raw materials offer a character and unique aspect that too often get overshadowed in our industrialized world. Wood floors are replaced by a composite look-alike. Petroleum-derivative plastics offer functional and economic gains.

When we walk around almost any modern city, we will see a lot of glass, concrete, asphalt, and coated metals, painted surfaces. Not much is pure, and for good reason—metals oxidize and rust, wood rots, most

stone degrades. Skyscrapers are not built of bricks or mud for basic structural soundness. This may be why cobblestone, tile, slate roofs, and granite sidewalks have such increasing appeal, and why many cities have stopped the practice of paving over their bumpy rock streets with asphalt.

I have witnessed public spaces ruined by the simple act of coating over the stones with asphalt, Pisa being a great example. And I have seen cities like Berlin and New York actually "undoing" their streets, taking out asphalt and returning stones to the streets. As jarring as the stones might be to drivers and cyclists, and as ungainly as they might be for women walking in high heels, these natural materials help soften and humanize the environment, thus attracting us to them. It is the same reason we like parks, fountains, and tree-lined streets.

But not all natural materials are compelling or beautiful. And processed materials can be rich as well on their own: blown glass, cheese, stainless steel, earthenware. Like so many visual elements, it is a balance or contrast of materials that appeals: a wooden window frame against a painted surface, a chunk of iron embedded in a stone column, an iron manhole sunk into an asphalt street.

I took this shot of fabric rolls in the back of a van at a flea market. It's a playful, colorful composition, but what makes it interesting is that the material alone is compelling enough without the human repurposing of it into dresses or curtains.

The Alhambra in Spain is universally acknowledged as one of the greatest works of architecture and public space—ever. It is rich in human engineering and fabricated forms, and equally rich in materiality, with a variety of raw stone surfaces and patterned, brilliant tile. Gaudí's works offer a similar inspiration, with a mix of iron and colorful ceramics embedded in the

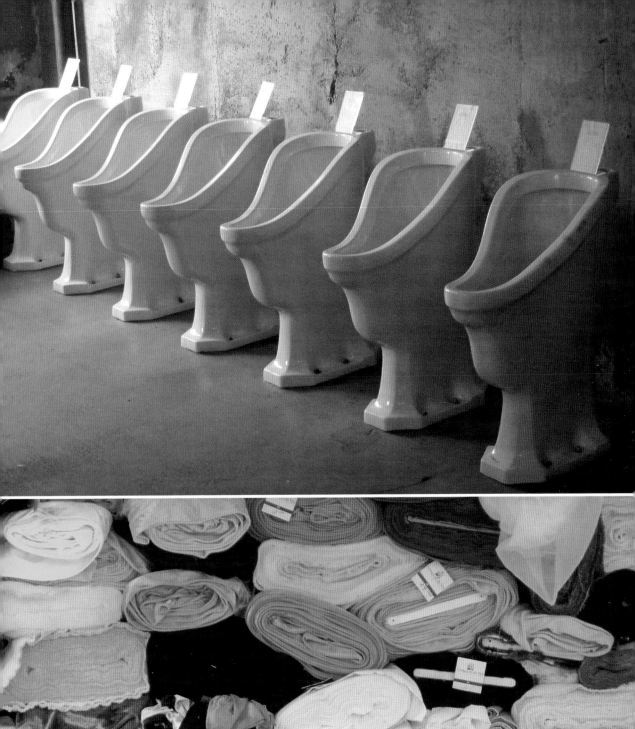
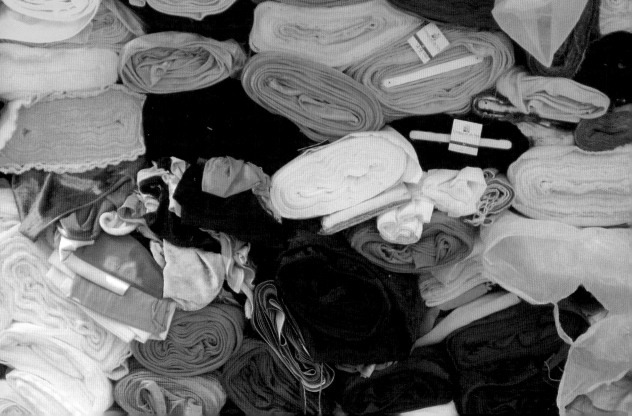

left
LAS CUMBRES

right
NEW YORK
BRAČ
BARCELONA

next
BROOKLYN
MILAN

structures. And many of the most acknowledged modern architects, including Peter Zumthor, Louis Kahn, Frank Gehry, and Tadao Ando, find ways to celebrate materials rather than to disguise them.

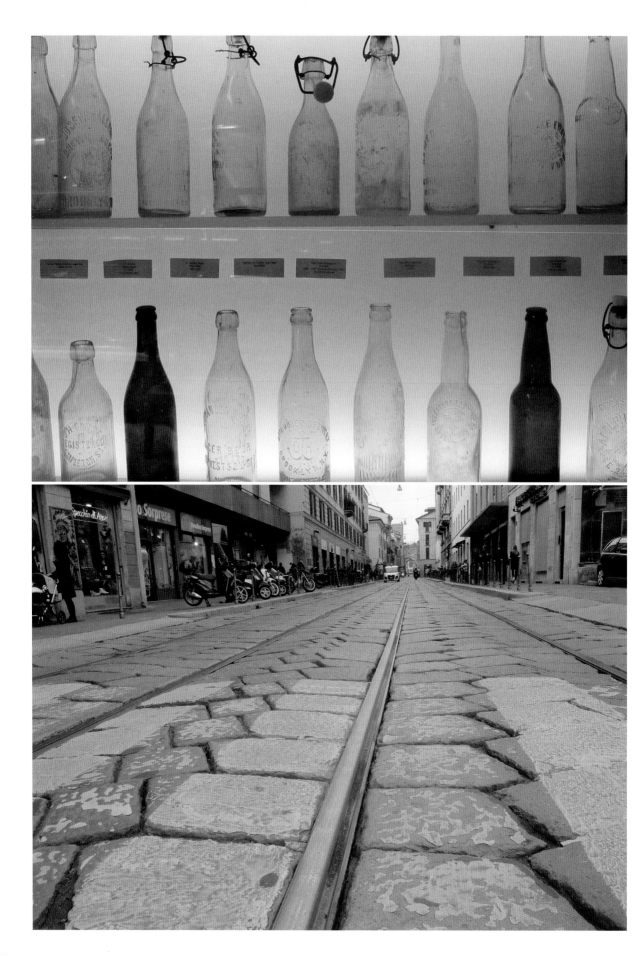

BIKE LOCKS
AMSTERDAM, NETHERLANDS

Walk around Amsterdam and you will be treated to exceptional diversity and beauty in the canals, bridges, and pedestrians. It is a highly visual city because of its intimate human scale and because everyone gets around on bikes, not cars. There are bike locks peppered all over the city, themselves studies in materials and textures and color as much as function. No two people are alike; in the same vein, there are no two identical ways to lock up your bike. The fact is that bikes get ripped off. Finding some visual pleasure in the diversity of the locks is at least a partial diversion.

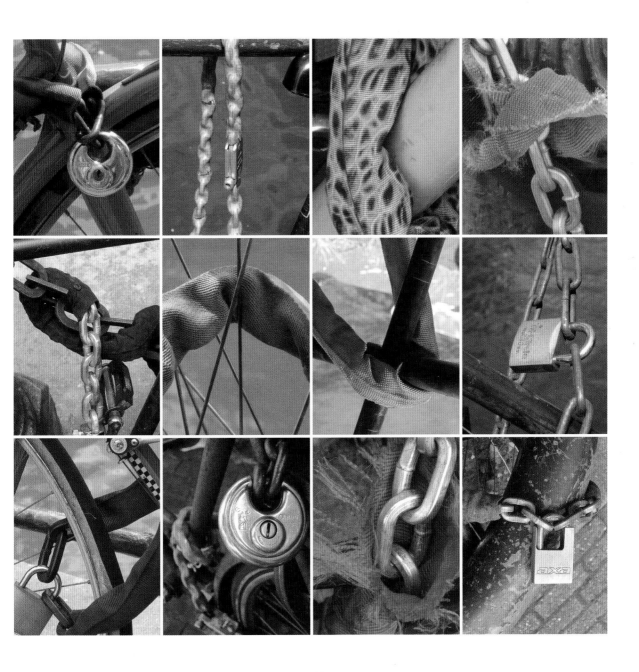

PATTERN

previous
SAN FRANCISCO

left
MIDDLETON
HOKKAIDO

right
CARTAGENA

114

I have heard speculation that 90 percent of our brains' activities consist of drawing connections among things, recognizing pattern.

This seems logical to me, as nearly everything we do or see is in the context of some interconnected system. Pattern is everywhere and undeniable, and only those people who have never tapped their foot to a melody, whistled a tune, written a letter, arranged shoes in a closet, or turned pages in a book can claim ignorance of pattern.

Looking closely at the patterns of kernels on a corncob, it occurred to me that part of our obsession with pattern connects to some primal comfort related to basic survival imperatives. Food identification, essential to survival, meant knowing the healthy from the poisonous plants, the fresh from the gone-off meat. Understanding these first patterns led to systems designed to facilitate survival. Patterns like these might suggest security; in today's world they might suggest abundance, that is, the larder is full.

Walking through farmers' markets, a carnival of fruits, vegetables, and cheeses, bowls filled with nuts and berries, beans, and grains, always puts a smile on my face—as repetitive and predictable as this activity might be to some. This is natural comfort food.

Pattern transforms common objects: baseball caps, lipsticks, construction material—anything. I seek out

There is a poetry
behind pattern.

117

left
CARTAGENA

right
SEVILLA
CHICAGO

next
CARTAGENA
AREZZO

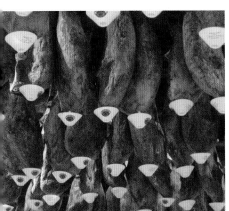

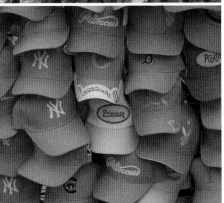

mundane objects because I find elegant patterns within, like these paper cups draining fatty oil off suspended cuts of prosciutto. Pattern imbues the simple gestures and objects of day-to-day life with an unmistakable beauty.

I often hear people say, "I'm just not a visual person like you designers." The recognition of pattern can be an inroad for those linear thinkers who consider design to be primarily for creative, right-brained people. The very definition of linear is, after all, a line. And a line is nothing more than a series of points in a row, itself a pattern. Insurance assessors and financial analysts use metrics to create patterns expressed as graphs and charts to assess risk. Lawyers seek out patterns in precedents and reiterate verbal messages to juries. The military uses it to camouflage people and airplanes. Mechanics time engines, baseball fans study RBIs, and masons set brick, all by relying on patterns.

Much of our formal education and training—reading, writing, and arithmetic—is based on rational constructs and problem solving. Pattern recognition is an alternate form of education connecting us with something deeper, with the irrational and emotional side of our nature. The value of this right-brained activity is difficult to articulate but no less meaningful to our well-being. There is a poetry behind pattern.

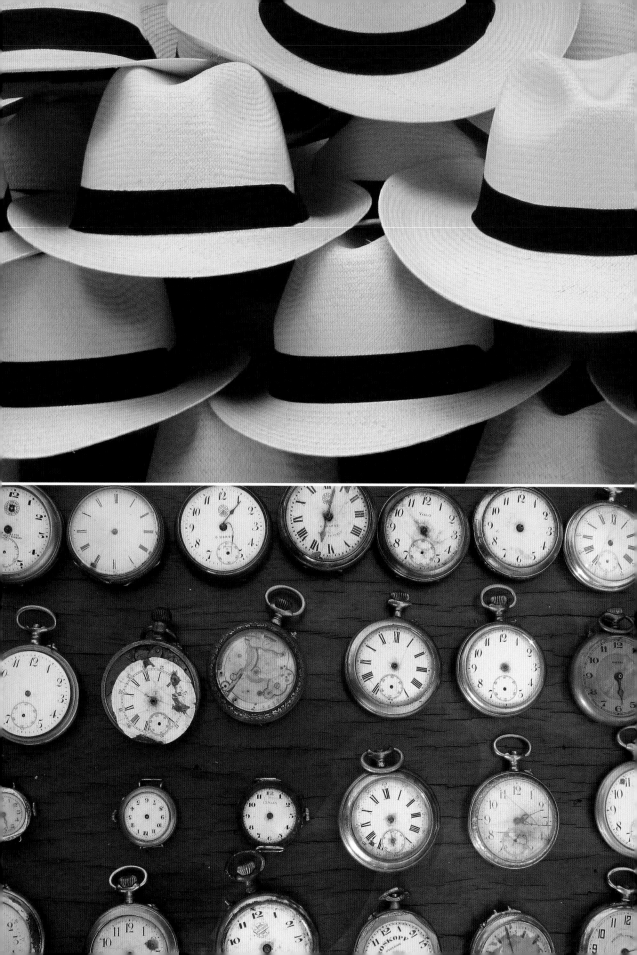

DOORS
BORDEAUX, FRANCE

I went to Bordeaux on a wine-tasting trip. Bordeaux is one of the most sophisticated, nuanced, and revered red wine regions. To appreciate the wines' nuances, it's best to taste several side by side while guided by experts—and even then it is tricky. I took a walk in the old part of the city after one of these sessions and, inspired by the wine, noticed how the shape of traditional Bordeaux doors mirrors the classic high-shouldered Bordeaux bottle. So which came first? Is there a connection? Does it matter? Both wines and doors reflect local culture and they are both important social statements. *In vino veritas*.

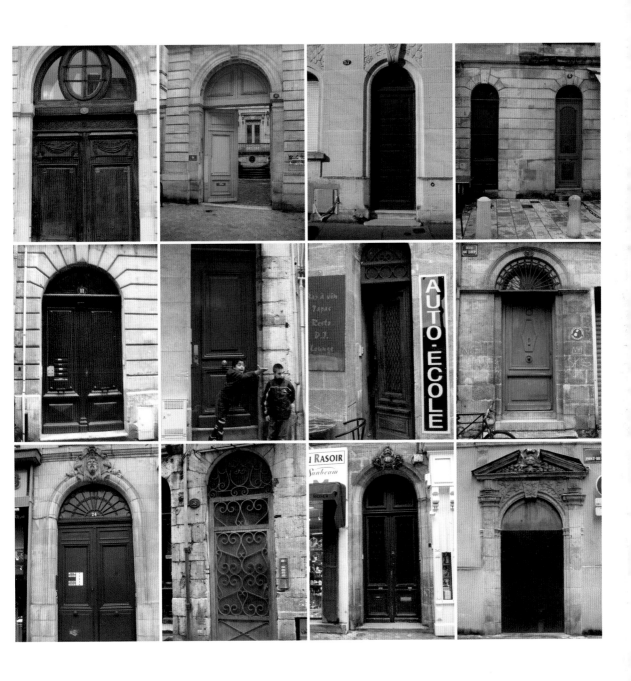

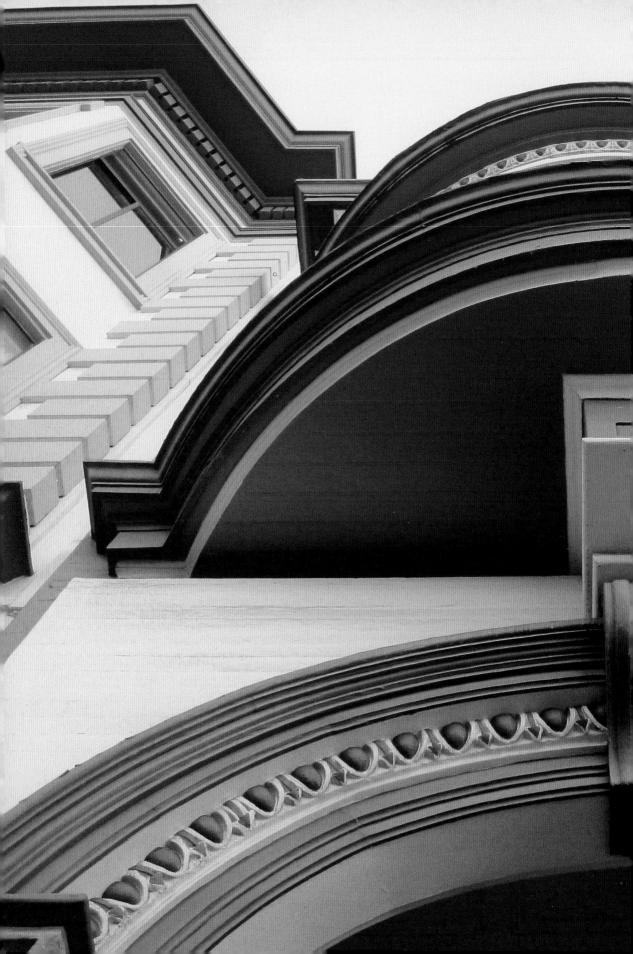

POINT OF VIEW

previous
SAN FRANCISCO

right top
NEW YORK

right bottom
NEW YORK

far right bottom
BARCELONA

122

————————
————————

As *Homo sapiens*, we generally walk upright and primarily view the world at eye level, looking forward.

In this manner we can see the farthest distances and take in the most visual information. It has been key to our survival as a species. But the world becomes a lot more interesting if we try to see it from another point of view.

Looking up from the ground, looking down from a tower, turning objects over, focusing closely on details, seeing the world as a child or a dog might, all of these shifts in perspective unlock visual doors, open vistas, and allow us to see more. It's the same education we get when we look at the world differently—when we take less-traveled streets, walk through a restaurant kitchen, or visit a theater backstage. Fresh perspectives help us see things more broadly and appreciate how things operate in the world.

The value of perspective—or point of view—was brought home to me once while having lunch with a food photographer who encouraged me to see food from the table's perspective. Toast heaves into a dramatic structure, and egg cups emerge as colossal towers. There are more photos of plates of food floating around these days because of mobile phones. The

standard view is bird's-eye, down on the composed plate. Maybe we will start seeing fresh views of how we experience a plate of food.

As a potter, I've made a practice of turning things upside down, often first thing. In that craft you learn that the undersides of pots, the feet, are where master potters display their talent, often in a subtle, understated manner. So you develop the habit of flipping over plates, cups, shoes, chairs, everything, and finding stories. It turns out that what you are *not* supposed to see may be more intriguing than what you *are* supposed to see.

Take a walk around objects (and buildings) to understand their full identity. I had to circle these sidewalk posts with a hydrant a few times to find a balanced perspective.

Take an object like a baseball—turn it around until you find a perspective that makes sense to you, and you'll see how curiously entertaining a point of view can be. Edward Weston turned bell peppers and seashells into epic studies in form—and all of us can embrace his approach.

A good adventure and education, especially in cities, is to look down as you walk. I've come to believe that the more boring and predictable the pavement, the more boring and predictable the local culture. And climbing city towers to gain perspective is a habit for me—an easy thing to do in countries like Italy where they are less fussy about building-code restrictions. I'm often amazed at how few people are willing to walk up stairs for a new point of view—and from my perspective, all the more reason to do it. Looking down the stairs at the Piazza Venezia in Rome would give us a markedly different reading than looking up them does.

If you are reading this in printed book form, do you know that the pictures are all composed of just four

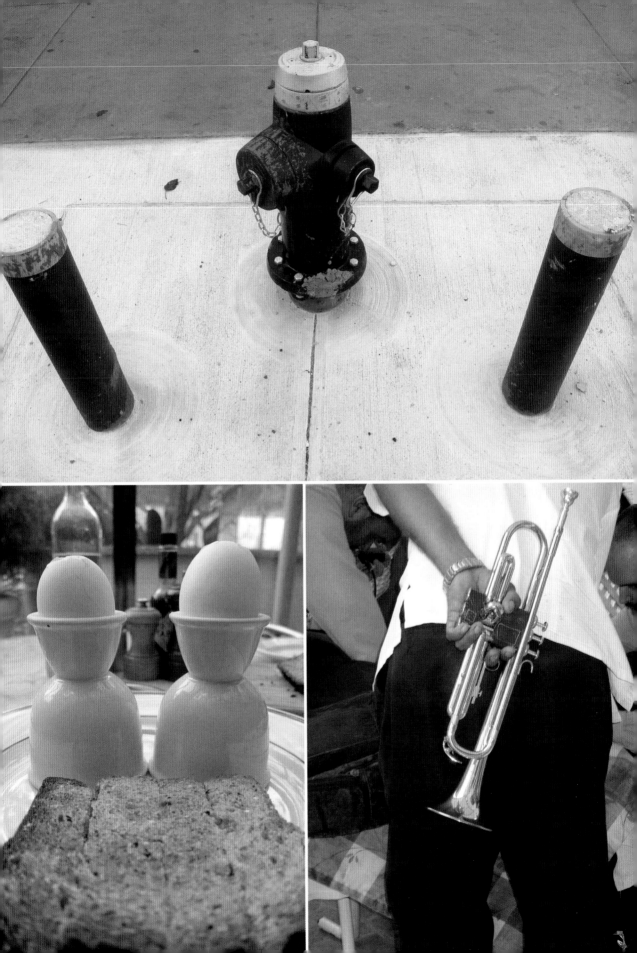

colors in dots? Find a magnifying glass and you will see them clearly. Another confirmation and exercise in seeing and perspective.

Technical advice: Cameras, by nature, give us a unique perspective. But the modern zoom and close-up lenses in pocket digital cameras are essential to me and play a part in almost every photo I take.

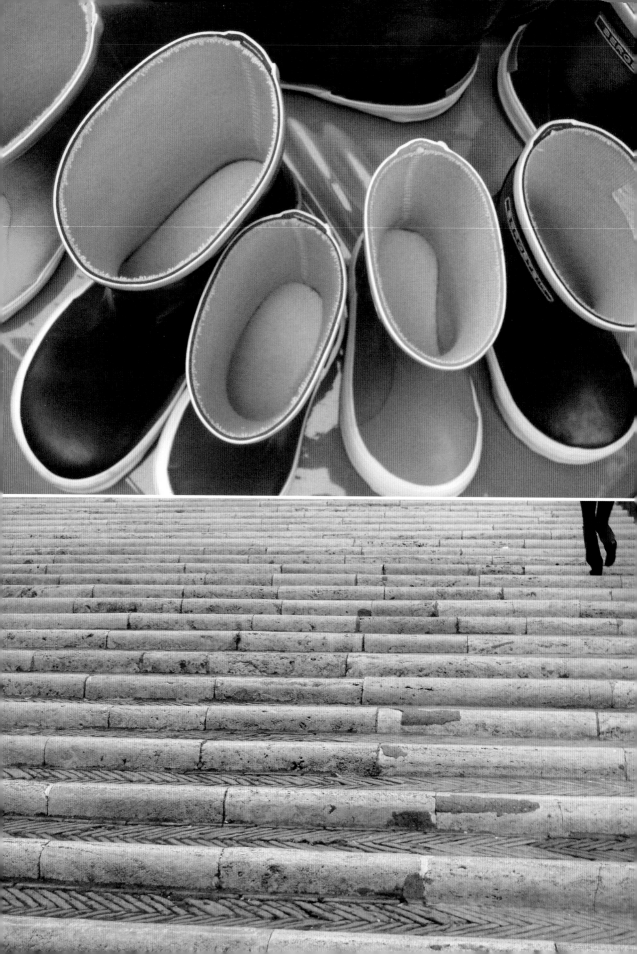

SEWER TILES
SAN FRANCISCO, CALIFORNIA

If you find yourself walking a street, neighborhood—or anyplace, really—and find no nuances, better run, fast. You are in hell. Nuances are what make us human and define character and personality. They remind us of the value of subtlety and humility.

Nuances have the power to turn these common sidewalk sewer tiles into amazing studies. Sewer tiles, the line goes, they don't get no respect. They are not discussed at cocktail parties. Most of us are unaware they exist.

It's easy to walk right over them with complete disregard. But time and nature and traffic have brought individuality and beauty to them in the form of nuances. If we train our eyes to see nuances in the everyday, we'll come to see and expect more out of everything— our buildings, our cities, ourselves.

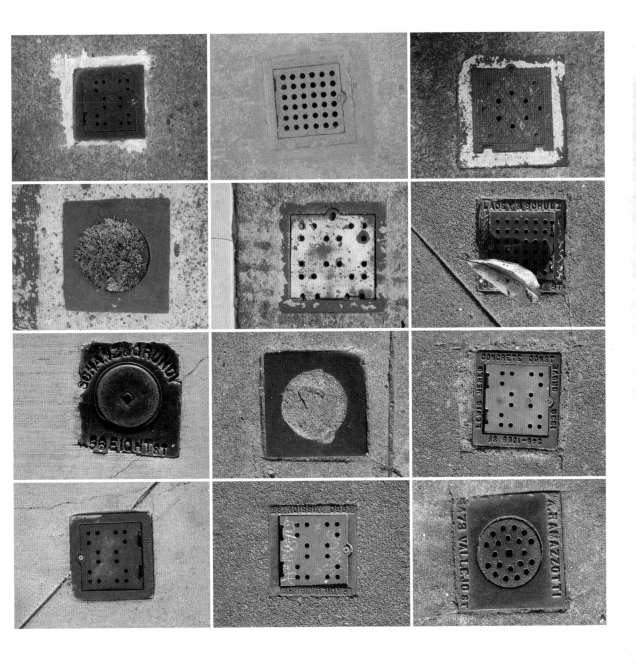

WE
SEE
WHAT
INTER
ESTS
US

FAMOUS BRIDGES
VERSUS
ANONYMOUS CATTLE SHEDS

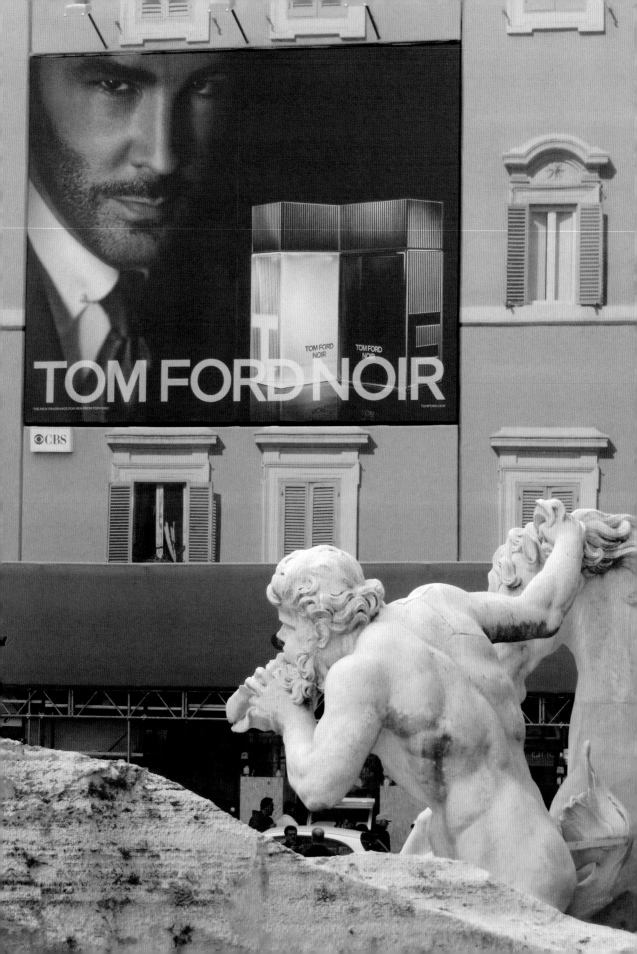

WE ALL HAVE preferences when it comes to where we direct our gaze—this sounds so simple and obvious, why even make a point of it? For me, the rise of ubiquitous technologies has moved me to put a stake firmly in the ground around seeing. I believe that, now more than ever, we all need to more deliberately and actively see the world. The shiny black mirror tucked into our palms, periodically calling our attention to a message or an image or an idea, the tablet inviting a techno-pen to scratch out digital messages—they take our eyeballs away from what is all around us. The lure of these objects receives increasing attention—books and blogs argue we are now "alone together"—and perhaps signal a waning collective experience. What can we do to be mindful of the real world? To be attentive to shared urban and other environments?

The fact is, we remain a species deeply connected to surviving and thriving based on what we see: Instincts direct us to see things that affect our safety and well-being; our preferences can direct us to see things that will teach us how to be, who we are, what we strive for. I made a study of fountains in Rome from an aesthetic perspective, while knowing that the design of water systems, beginning with aqueducts in the third century BC, is at the very core of the development of Rome (and of Western civilization). The fact that they now have become watering holes for tourists and for commercial fashion billboards, as with this shot of the Trevi Fountain, says much about our changing cultural values. And the ubiquitous public drinking fountains in Rome say much about the Italian cultural belief that good clean drinking water is a basic human right.

right top
ROME

right bottom
AMSTERDAM

far right bottom
NEW YORK

132

COMMON GOODS

What draws my eye? Often it is the familiar things all around us: buildings, spaces, chairs, plates, sidewalks, benches, bottles, road signs, fences, and stores. These attract and engage me in the same way others fancy fashion, art, celebrities, porn, or hikes in the woods. I'm particularly inspired by humble and prosaic goods found on the streets, in places with equal access to everyone. If we can learn to find beauty in these common things, it follows that we can find beauty almost anywhere. It is also the democratic nature of these things found in the public world that gives them special meaning and value. The High Line elevated park in New York, for example, is of greater value than anyone's private garden, just as cafés offer more than the personal kitchen. Trains are more compelling than cars, and museums' collections offer greater potential than our living rooms.

These public goods say more about our values as a culture and mean more to more people than our private goods. And when we get them right, they might be some of our greatest statements and achievements as a species, true wonders of the built world. My list is endless, but favorites range from Sonoma Plaza in Northern California to Grand Central Terminal in New York to the Pantheon in Rome, places I always return to because they are places that have an inherent optimism. However, any useful common public space, sidewalk, promenade, square, or market can have a similar value, as these places touch and shape thousands of people every day. They dictate the way we engage with our species and thus define civilization to a large degree.

Within this public domain, there are two themes that surface in my photos. The majority of photos in this book deal with aspects of either utility or unintended design. There are compositional elements at work in every image —balance, beauty, or interesting juxtapositions, for instance—and I use these visual elements to bring attention to the subject matter. But my overriding obsession is rooted in the functional (utility) and especially in those things not created or intended to make a design "statement" (unintended design) but that wind up doing so. A famous bridge and an anonymous cattle shed might help make the point.

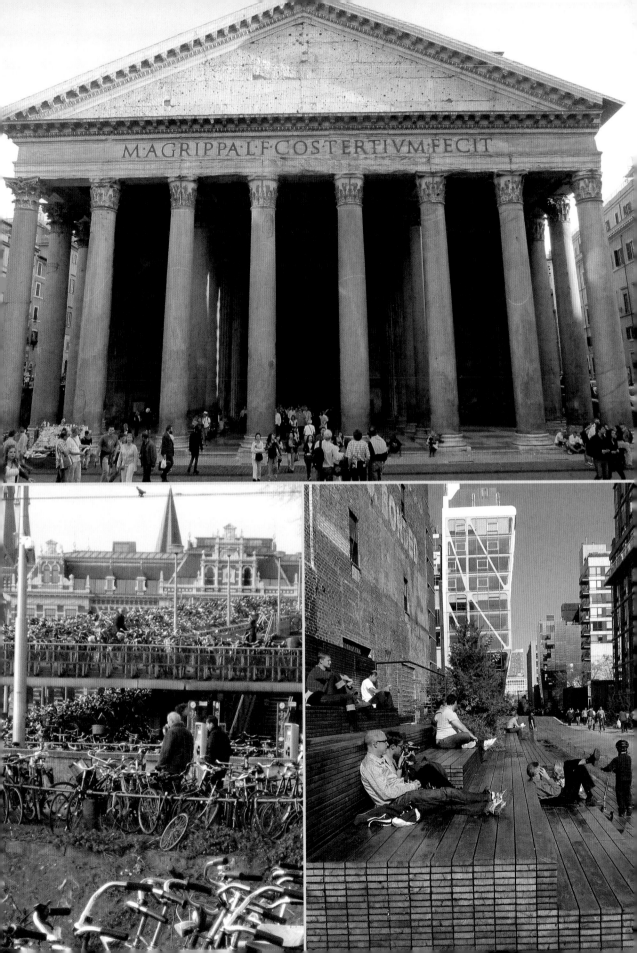

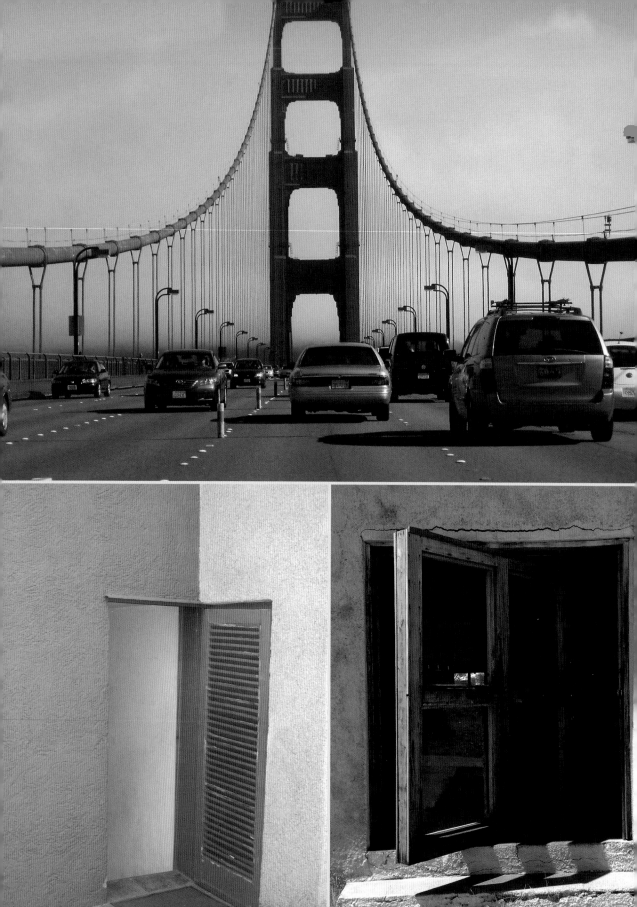

135

left top
SAN FRANCISCO

far left bottom
MEXICO CITY

left bottom
MARFA

UTILITY

Sixteen million visitors come to San Francisco each year, and ten million seek out the Golden Gate Bridge. Along with China's Great Wall, the bridge is one of the most visited pieces of design in the world. I have ridden my bike over it hundreds of times and know its look and feel intimately. I think it is the utility of the bridge that makes it so compelling, more than its commanding structure, color, and beauty. The bridge is breathtakingly dramatic, formidable, and majestic. But if that is the test, so is the Grand Canyon. So what distinguishes the two? I believe it is the Golden Gate's extraordinary utility. This is what deepens its meaning and value. The bridge allows people to stream across the water. It facilitated a new economy. It changed the social dynamics of the region. People rely on it every day. Yet because it is so much a part of the Bay Area landscape, we can forget a group of human beings imagined, designed, and built the bridge—and some died doing so.

It is a statement of our potential as humans, it reflects our optimism, and it inspires us to believe in something larger than our individual lives. This is utility at its best. This is intended design.

In our culture utility does not get the respect it deserves, in my opinion. A great designer can elevate it to the public, these two doors, one by Luis Barragán and one by Donald Judd being examples. But in the hierarchy of cultural value, utility takes a back seat to loftier visual pursuits such as painting, sculpture, or architecture.

Great utilitarian design is seen in America in Shaker furniture and Amish quilts, in the barns of Iowa and the covered bridges of New England. Resurgent interest in mid-century modern indicates that when given the option, many of us do value and choose beauty in utility. But we have to be taught and reminded to see it, in contrast to a culture like the Japanese with a long-standing tradition of placing tremendous value on tea bowls, knives, umbrellas, and other functional objects.

UNINTENDED DESIGN

A cattle shed in Vals, Switzerland, is a good example of unintended design. I went to Vals to view the amazing hotel/spa Therme Vals by Peter Zumthor, who won the prestigious Pritzker Architecture Prize. His spa is a world-class destination for designers. And right across the valley, we find other world-class structures, designed to keep cattle warm and fed in winter. Not many visitors climb the hills to see these simple structures, but they actually share many common aspects with the fancy spa: simplicity, superb use of materials, no false decoration, purity, and connection with the landscape. What these outbuildings show us is that when left to our own devices, and when we focus on serious functional concerns like survival and avail ourselves of honest local materials, we humans can demonstrate a remarkable sense of proportion and beauty. The similarity of structures—teepees, yurts, lifeguard towers, and tents—created all over the world by unschooled architects and builders proves this point.

There is simple delight and amusement in this activity of seeing, but a lot more underneath. People-watching ranks at the top of the list for many of us, as the importance of our human relationships and our identities trumps most other issues. But after that, what do we willingly choose to view—and why? It is often voluntary and undertaken for basic stimulation.

Another example of unintended design is a gas station on Martha's Vineyard in Massachusetts. The structure and lighting stopped three of us in our tracks one night. We were walking from a parking lot into a restaurant and each of us had the same visceral reaction and attraction. There is a lot of design at play here visually, but I doubt that much of it was intended. First—it's cute! It looks more like an endearing dollhouse than a commercial service station, and making a gas station appear friendly is a feat in itself. Gas stations are usually colossal efforts in branding, but this one asks us to consider a landscape free of overpowering logos. There is a powerful symmetry at work, supported by many elements, especially by those round clocks and the American flags set at angles. The color selection appears intentional, a study in primary colors that Mondrian might have approved of. (Toss in some purple and the composition collapses.) This seems to be a very considered modern piece of architecture, with nice contrasts in the vertical and horizontal elements, all helped by the nighttime lighting and shadows.

This scene is a refreshing alternative to the polished and intended design we see along the road: commercial ads, billboards, banners, and other forms of marketing that are designed to sell us something or to manipulate us in some way. We are a marketing-driven consumer culture with aggressive visual messages coming at us at almost every turn. Just as we turn off commercials on the television or block them on our Web searches, I avoid them as much as possible on the streets. It is this search

137

next left
MARTHA'S VINEYARD
SONOMA

next right top
UTRECHT
SAN FRANCISCO

next far right top
VALS

next right bottom
STINSON BEACH

next far right bottom
PANAMA CITY
SAN FRANCISCO

for more curious and idiosyncratic messages that makes this practice such a fun and worthwhile game. And I think this is at the heart of my interest.

A common intersection in Sonoma is another example. There is a lot going on here: more than fifteen different messages, a menu of sorts, all intending to have some utility. It makes us question—or laugh at—the very nature and purpose of signage, and how and where these decisions are made. The composition is charming, in its own idiosyncratic, modest, cluttered, unplanned, yet visually balanced way. But there are formal visual elements at work: The arrangement of horizontal and vertical lines is offset by enough angles in the trees and signs to keep your eye moving. But the story behind how this collage came to be, and what it says about the way we as a culture create public messages, is the curious unintended design element. I wish I had been there to capture the guy who scaled that tree to nail up his gopher-trapping pro-motion. The entire visual mélange is so endearingly human, so delightfully authentic and unprofessional.

Unintended design is all around us—if we choose to see it that way. Hanging laundry is a common and favorite subject of mine, often amazing arrays of color and texture that get unwittingly displayed for public viewing, banned in many cities in the United States but common elsewhere. Stacked paper cups piled on a counter can be viewed as towers of curves. The back of a service truck with coiled hoses in red and green served as a Christmas card for me last year. Exposed commercial plumbing and construction materials can make for compelling studies in form and materials. But they are often hidden from sight, buried in walls, snaking under our streets, and performing daily chores that go largely unacknowledged, a Cinderella of design.

A professional fashion photographer friend of mine shoots exceptionally elegant and sexy models. He does gorgeous work. He told me that he thought it was much more inspiring to discover and record beauty in stuff that is not inherently beautiful or which we have not been conditioned to appreciate. I agree. The beauty lies in the process and the perspective. It reminds us in some way that we have the power to see the world as we wish to see it. "Beauty is in the eye of the beholder," as trite as the saying may be.

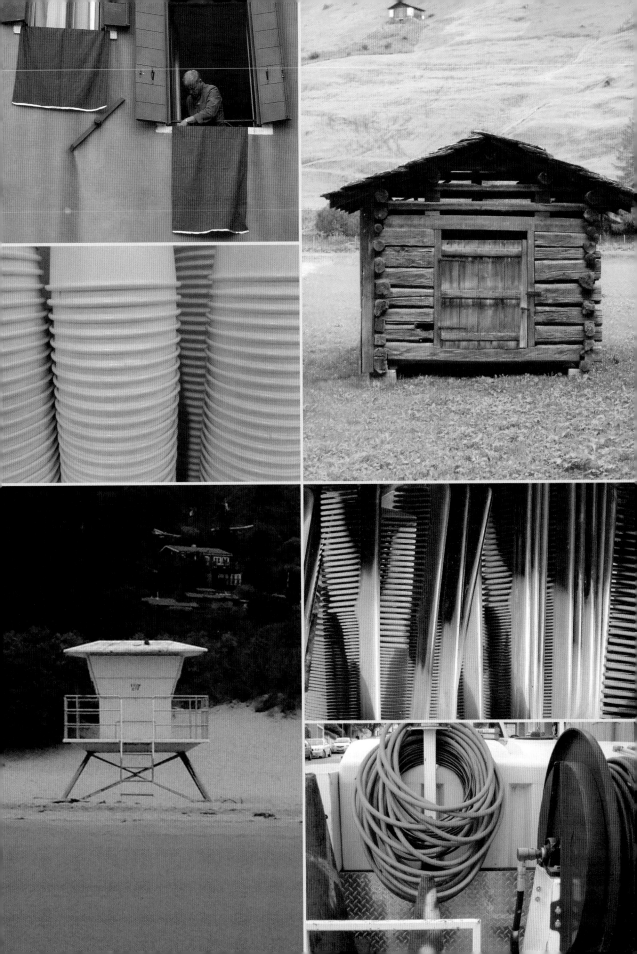

REPE
TITI
ON

previous
PANAMA CANAL

right
MUIR BEACH
PANAMA CITY

142

We all seek order in our lives, and repetition is a favorite tool.

Repetition makes satisfying, and at times poetic, compositions out of even ordinary objects: bottles, combs, tools, plates, shoes, urinals—anything. A wall of books is one of the most common and serene visual expressions of how repetition brings order to our living spaces. Like pattern, repetition directs and orders our sight. But repetition carries with it conviction and commitment. We like this, but only to a degree. Too much order becomes regimentation and can turn us off: for example, rows of tract homes repeating architectural style, lines of goose-stepping soldiers, shelves of consumer products unvarying in color, size, or message.

Repetition becomes most interesting to me when it breaks down a little, thereby asking us to think about when enough is enough of the same thing. These ice cream scoops I spotted on a café wall in Panama City are a good example. I would not have noticed them had the repetition not invited more careful scrutiny. Lined up imperfectly, the scoops become happy characters in a friendly marching band; they are further animated by the nuances and variations in color and patina. No two are the same, and this is what creates texture in the composition. The same is true for men sitting on a wall in Lecce, Italy, umbrellas in Miami, and motorcycles in San Francisco.

Modern industrial production allows us to produce objects in mass that are visually indistinguishable. So much sameness quickly becomes tedious to the eye and spirit. But why does this standardization bother us, really? Because we object to conformity as a principle? Maybe our emotional discomfort is rooted in the fact that in nature, no two things (rocks, trees, people) are ever exactly alike. We exist in a world that tells us individuality matters. The heart of creativity resides in straying from standardization. And creativity defines us as humans.

My awareness of repetition dates to childhood. I clearly recall a military base in Long Beach, California, we drove by every Sunday: defunct, round, gray naval mines piled, heaped, tossed up in a series, stacked for about a mile. The scene mesmerized me. Perhaps a piece of my interest was the inherent power of the explosives. However, I find the same interest as an adult in stacks of hay bales, or steel drums piled up in Panama.

Perhaps the appeal of repetition lies with its inherently constructive nature and the sense that we use it to create shelters and protect ourselves: wall, barricades, log cabins, fences. Kids like building things with blocks. Repetition is at work in protecting us from adversaries. Maybe those explosives were compelling for this reason?

Artists deal with repetition all the time—and Donald Judd as well as anyone. I recently saw an installation of his work at the François Pinault Foundation in Venice. The installation was composed of a series of wooden boxes of the same dimensions, lined up horizontally on a wall. On first look, or depending on the angle from which you approached them, they might have appeared identical, but slight variations inside

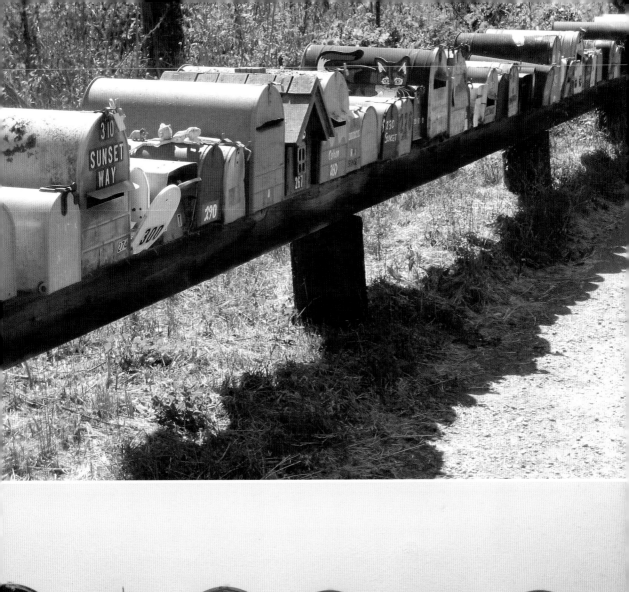

far left
LECCE
SAN FRANCISCO

left
MIAMI

right
CARTAGENA

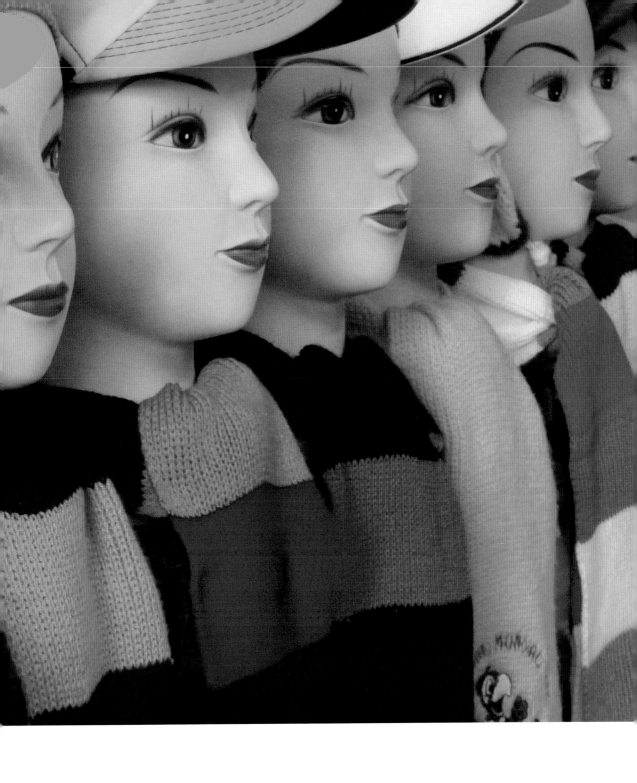

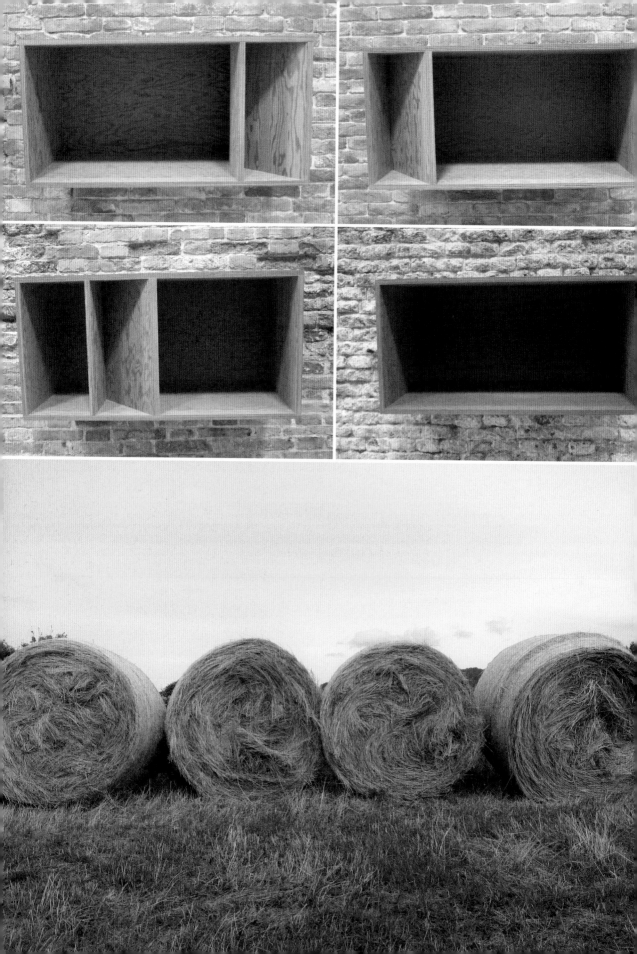

Repetition creates order and often invites us to look more closely.

left
VENICE
TUSCANY

next
VENICE
WASHINGTON, D.C.

each box prompted a comparison of the nuances among the series. A few days later I came across fields of hay bales in Tuscany. The bales were round and organic and straggly and without an obvious connection to the rectangular Judd boxes. But after seeing Judd's work, I was primed to cross-reference the minute variations of form between the bales. Repetition creates order and often invites us to look more closely.

Repetition is one of the most formidable tools in architecture and one of its most enduring characteristics. Piazza San Marco in Venice is best known for the Basilica of St. Mark, a sumptuous historic structure. But there is a building on the north side I always return to and appreciate more. It was designed by Jacopo Sansovino in the 1550s and finished by Vincenzo Scamozzi later that century. There are repeated columns and arches and circular windows in a form that could seemingly go on infinitely, circling the globe, a world of form, repeated. Horizontal shapes contrast the arches, creating a sense of balance, theater even. This building makes an impression on the soul. Repetition is the underlying principle that makes this possible.

Maya Lin's Vietnam Veterans Memorial in Washington, D.C., is an astounding expression in repetition, rendering the more traditional war memorials—statues of single soldiers or horseman—less compelling in communicating the ravages and heroism and personal sacrifices of war. It carries with it the power of cemetery repetition. And I believe its power and beauty will endure as long as that of the great Venetian buildings mentioned.

Looking to park my scooter one morning in San Francisco, I found the parking slots to be filled almost entirely with red motorcycles of similar hue and scale, as if by design. But the repetition was a random occurrence, making it all the more provocative, as if a silent hand had been at work.

...RELL · ROBERT S HOLLEY III · GARLAND D FLOYD · DUANE R K...
...E L KING · ROBERT E KING · RONALD E KNIGHT · FRANK E KOB...
...· ABBIE E LEAZER · ROBERT A LEWIS · JOHN S MANFERDINI · T...
...NICHOLS · SANTOS SILVAS NUNEZ · BARRY L OSBORN · ANTH...
...PHER J RICETTI · WILLIS ROGERS Jr · PATRICK A RUSSELL · FELIPE...
...G SONNEBERGER · BILL H TERRY Jr · RICHARD J WHITEHOUSE...
...N R WORKMAN · THOMAS S BONVENTRE · JOHN R DRISCOLL...
...RT A GRIFFIN · AMBROSE GASSAWAY · JOHN W GLADNEY · DR...
...V HUBBARD · CHARLES F HUGHES · JOHN C JAVORCHIK · THO...
...EY W MARTENS · FLOYD J MATTHEWS · JOSEPH J MEYER Jr · TIM...
...NY E McIE · WILLIAM R McNELLY · MICHAEL D NOONAN · RAYM...
...R · STEVEN M STICKS · DENNIS W SYDOR · LANCE W St LAUREN...
...ES M WITHEE · JOHN C WOOD · THOMAS J D CAMPBELL · APO...
...SWELL · DAVID E FOGG · RALPH J GREER · HERMAN H HUEBNER...
...NES · CECIL V MILLER · PATRICK E McGOVERN · LEON V PARKER...
...JHN J SESLER · LORENZO TUGGLE · JOHN A WELSFORD Jr · SAM...
...MAN · DENNIS BAGLEY · ALBERT D BENSON · KURTIS A BERRY...
...ONALD W CARDONA · THOMAS R COLLINS Jr · JAMES L DAVIS...

MAILBOXES
MARIN COUNTY, CALIFORNIA

Personalized mailboxes deliver a particular message—one of invitation, welcome, and play. How different they feel than mail slots in doors or e-mail addresses. They remind us how creative we can be—when we feel free to make aesthetic decisions about craft. These mailboxes were not driven by a building code forcing diversity in mailboxes. They just ended up that way, most likely after one brave soul decided to have some fun. Their friendliness is a function of their individuality, and witnessing locals doing their own thing collectively carries a message of optimism.

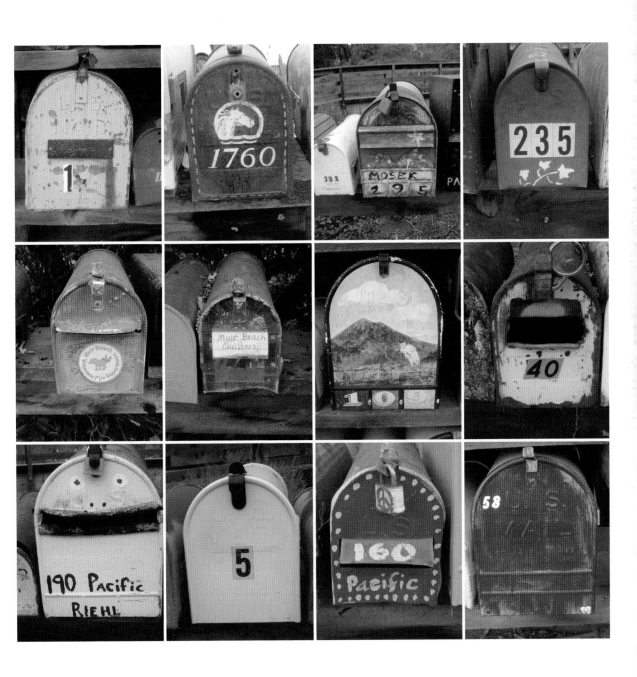

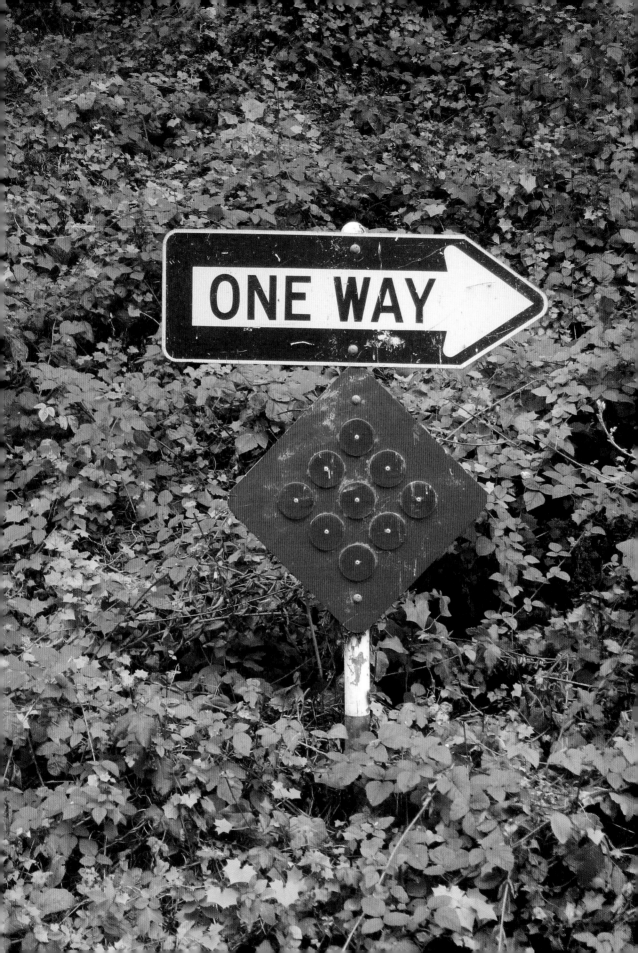

SIMPLICITY

————————
————————

The irony about simplicity is that it is a very complex thing to define.

Many of us consider simplicity the defining characteristic of good modern design. But the word has many connotations, not all of which are positive: Simplemindedness, for example, is not such a desirable attribute. The designer John Maeda offers this interpretation. In *The Laws of Simplicity* (MIT, 2006), he wrote, "Simplicity is about the unexpected pleasure derived from what is likely to be insignificant and would otherwise go unnoticed."

In our daily lives, many products fit this definition and often go unnoticed: paperclips, chopsticks, zippers, Post-its, toilet paper, forks, and so on. Simplicity crops up in the public world in myriad manifestations. This stone street marker in Spain defines simplicity at work. It is easy to read and takes up little space, allowing travelers to take in the countryside. And the stone markers do double duty, reflecting local materials and traditions. We drive by and take the directions, but the marker itself gets taken for granted. Much modern signage is not so easy on the eyes or the landscape.

Manhole covers represent a common utility and simplicity—they are found on streets and sidewalks all over the world. They are hard to improve upon, which is reflected in the fact that they have changed little over time. Every now and then, you come across manhole covers with some special charm in their modesty or personality. The same can be said of fire hydrants.

Seeing traditional street lines being painted gives me some sense that our established methods of graphic communication still have value and that they do not all need to be replaced by complicated digital systems. A basic red stop sign is one example of a simple object whose impact on our behavior eclipses its small size. I adore simple solutions for hanging laundry, like a stick-and-twine solution in Portugal.

As our modern lives become more complex, our appreciation of simplicity expands. I see many signs of this in our cities. Sandwich signboards are back. Clear glass water bottles offering tap water have replaced imported water in restaurants all across America.

I think the growing appeal of bicycles, across generations, is another good example of the desire for simplicity. The bicycle is a very economical design that finds applicability in almost every culture around the globe. Even in our cities where there are multiple forms of transit, the bike is often the fastest and most efficient way to get from A to B. With computerized engines, cars have lost their simplicity, and much of their personality and charm as well. With bicycles, we can still work on them and feel closely connected to their simple mechanical nature. And this makes them endearing.

————————
————————

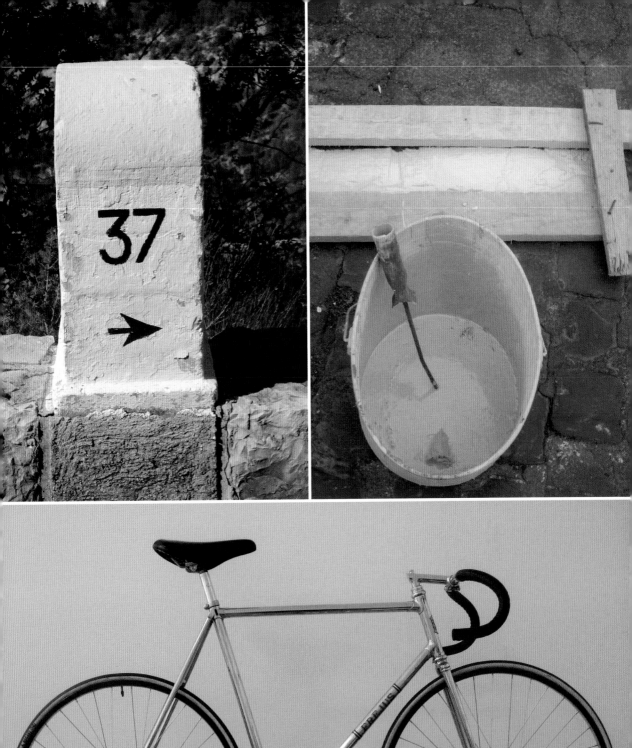

FOOD CARTS
CARTAGENA, COLOMBIA

Fast food in Cartagena takes a different form than elsewhere in the world. Stand or sit almost anywhere in the city and something refreshing will roll by in carts as diverse as the foods being delivered. It's a concierge service made possible by streets that are kept safe from car traffic—splashes of color and texture coming by all day and night. Improvised from supermarket shopping carts, bicycles, or simple crates, food carts all rely on the simplicity and magic of the wheel to get around.

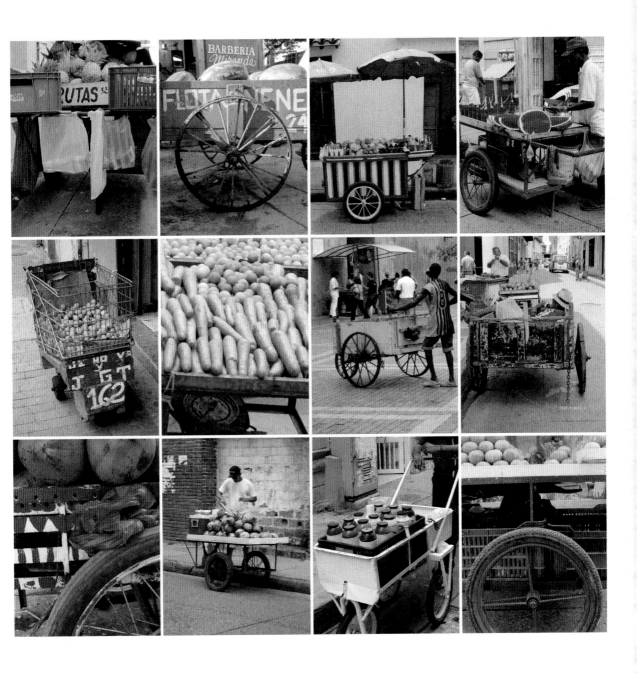

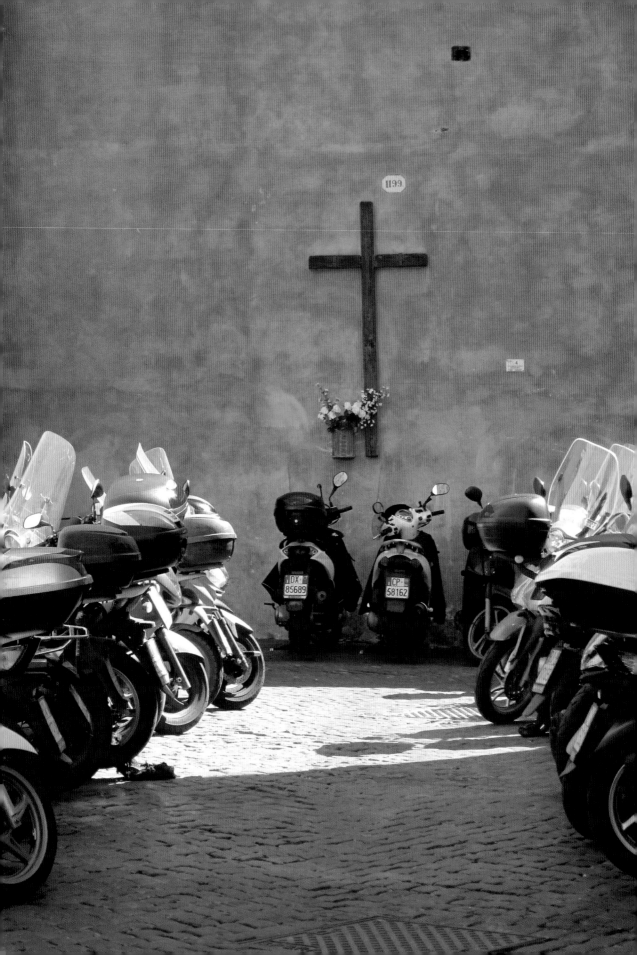

SYMMETRY

previous
ROME

left
TAIPEI
TURIN
MILAN

right
CHICAGO
CARTAGENA

158

Symmetry is an ordering principle like balance; its effect is to make disarray comprehensible, even pleasurable.

The built environment is full of intentional and incidental symmetries—while many of them are small, they explain why a larger composition is harmonious—the way we slice a sandwich in half, forming two elegant triangles, the way earrings dangle and frame two sides of a face, the way windows often frame a door. A pair of things has a certain potential that larger sets do not—and holds true for couples as well as inanimate objects.

Symmetry is also a powerful tool in a photographer's arsenal. It is often at the core of my compositions—if I don't find it, I create it through framing. Often, I am struck by instances where a baseline symmetry is offset by some detail, some tweak, creating a tension that makes the symmetry more pronounced. These headless mannequins in Taipei are a good example. If they had identical tops, they would not draw our eye. These twin archways are made interesting because one has a pipe connected to it and the other does not. The two mailboxes have different messages on the surfaces.

If there were only one dog on this sidewalk, I probably would have walked right by. But the fact that there are two, in similar shape and size, both curled up

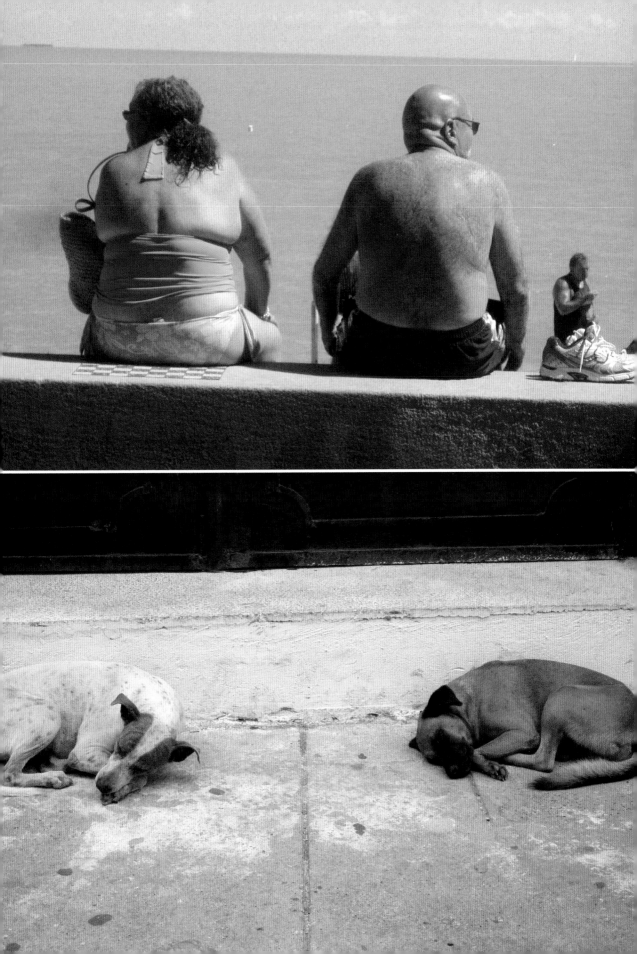

the same distance from the sidewalk crack, gives the image a sense of intentional choreography. Even their tails appear to be staged.

I came across these two wheelbarrows on a remote island in Panama; many provocative, eye-catching things surrounded them. But I am quite fond of wheelbarrows. They are an undervalued species in design. The fact that they are used and appreciated all over the world makes them even more endearing. In this case, it was the paired symmetry—and the fact that, without any intentionality, they were so artfully placed in the middle of a tiny island.

Most of these studies in symmetry were more than serendipity. When I am engaged in actively seeing the world as a photographer, I look for opportunities to create compositions. There was nothing inherently symmetric about an alleyway I saw in Rome, except the cross. But I saw the chance to create symmetry in the foreground: The scooters give it depth and some delightful and engaging juxtapositions.

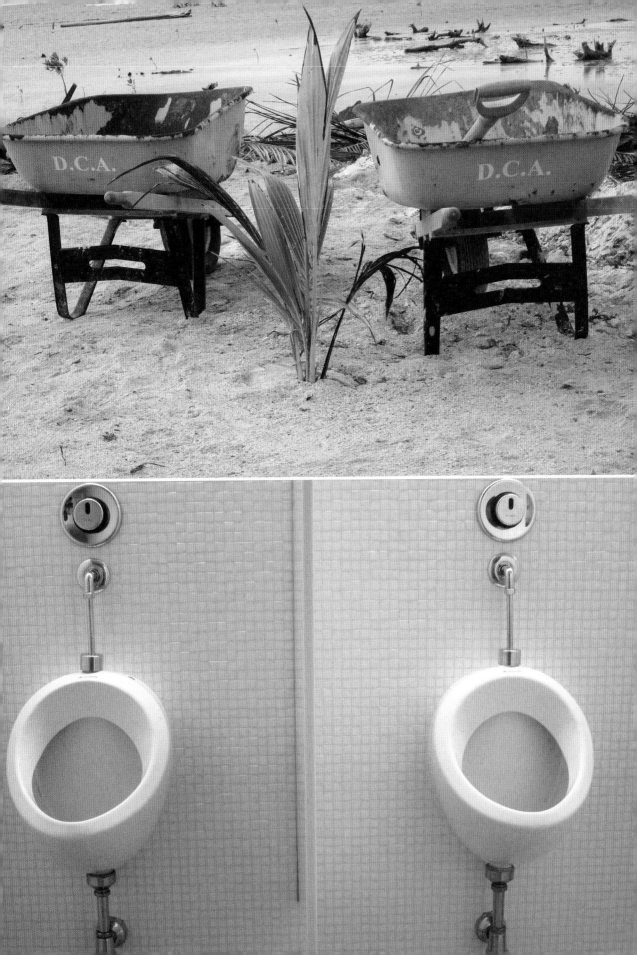

WINDOWS
CARTAGENA, COLOMBIA

In Colombia we find a compelling view of Spanish design influences in a colonial history dating back to the sixteenth century. In Cartagena, I found myself rethinking the very definition of a window. Frames, shutters, mullions, awnings, and lintels. What a delight to take them in—a sharp contrast to modern architecture, where windows often present as merely functional: clear glass, metal frame, standard size.

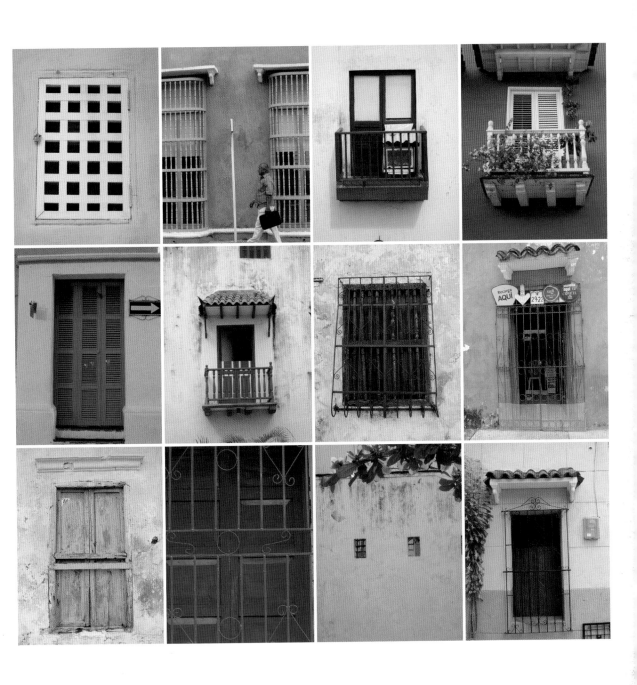

TEX
TUR
E

previous
ROME

right
OAXACA
SAN FRANCISCO

next far left top
SANTA CRUZ

next left top
NEW YORK
OKLAHOMA CITY

next left bottom
MILAN

166

Texture is most frequently thought of as related to the surface of things.

We rub our hands over a surface, feeling its smooth or coarse or varied character. We appreciate it in brick walls, shag rugs, and cashmere sweaters, and occasionally we get treated to some spiky texture from hair-styling gel, which shares a common effect with the cactus.

But texture is equally a quality that takes us beyond the surface. Texture is what gives a book, person, or piece of music depth. Texture is often what meaning comes from. It is the antidote to superficiality, and this is why we value it in the common things we come in contact with.

The cleanliness and formality of modernism has severely reduced texture in our roads and structures— indeed in nearly everything we see and use. This is neither good nor bad, but it may be why antique stores and flea markets, rich in older goods with patinas, nuances, and evidence of handwork and age, have ever-increasing appeal. We also see artificially distressed clothing and furniture created to meet our desire for texture. That's how badly we crave it.

The texture of a city invariably affects us. What gives a city or place texture is the mix of people, buildings, shops, cafés, windows, sidewalks, parks, old and new stuff, side by side. Variety. This is why New York and San Francisco lure tourists from all over the world. In New York, it's the density and diversity of culture and the liveliness of the city at any hour. In San Francisco, it is the hilly topography and diverse neighborhoods. I also see texture in the mix of vehicles on the hills: trucks, trains, bikes, buses, cable cars, streetcars, scooters, and skateboards.

I have two routes that I can take to work: the Bay Street–Embarcadero corridor or the Polk Street–Market Street path. In a rush, I take the former; it is efficient, well paved, and predictable. When I need an emotional boost, I choose the latter; it is rich in pedestrians and stores and street life. It's the same reason tourists flock to Fifth Avenue in New York or the Spanish Steps in Rome.

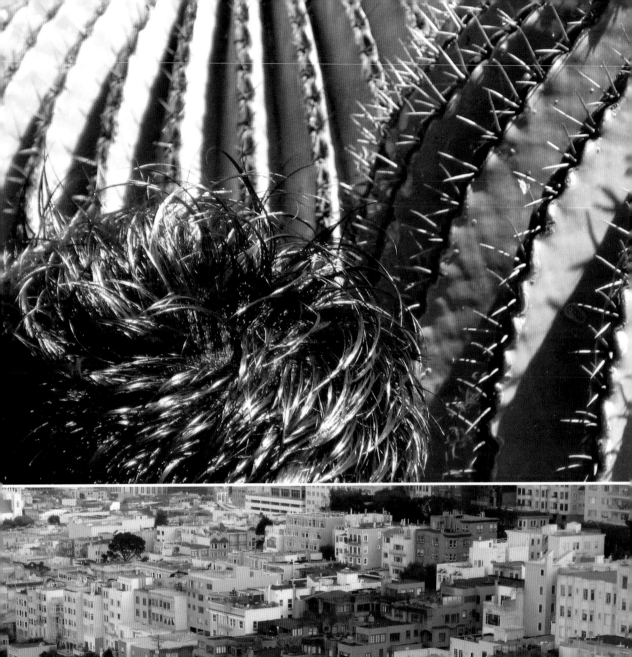

SIGNAGE
TAIPEI, TAIWAN

Taipei is at first blush one of the least visually interesting cities I have ever visited. The downtown is a sprawling grid of wide, traffic-packed streets; there's anonymous architecture and a dearth of parks, and the overall design is hostile to pedestrians. But like many modern cities, the back alleys and side streets offer some relief. Against this backdrop, it's no surprise signs are what stood out to me, with their variety of color, patterns, and elegant Chinese characters. Sometimes it helps not to know a language—it allows us to view graphics symbols and marking in an abstract manner, free from their commercial or functional intent.

SEE
HERE
NOW

===

**THE VALUE
OF SILENCE**

===

previous
ROME

right
ROME
PANAMA CITY

172

A FRIEND OF mine leads groups on hour-long nature walks down the oceanside cliffs, during which the group is not allowed to talk. Only at the end of the hike do they discuss what they experienced, with the idea being that silence allows our other senses to take over, so we can smell, see, and hear more acutely. This exercise is designed to keep your mind alert to what is really around you in the moment. You could, of course, take this same nature walk and spend the time chewing on thoughts about work, politics, relationships—all the stuff that circulates through our minds—and end up seeing very little of your surroundings. A quote from the Gregorian monks of the Grande Chartreuse is apropos: "Only in complete silence one starts to hear; only when language resigns one starts to see."

If you apply this same exercise—walking through a city or community without talking—and concentrate on just using your eyes, I'll wager that your awareness of the world around you will be dramatically altered, both in character and in vibrancy. Doing this with a camera, and with an objective to find things, increases the exercise's visual intensity and focus. A sketch pad or notebook, even if you have the rare talent for recording images this way quickly and accurately, does not allow you to use your eyes to create composition so quickly, to improvise so readily from various perspectives. As extraordinary as our eyes are, they cannot compete with zoom or wide-angle lenses, nor can they frame images into flat compositions. And the blessing of digital cameras is that mistakes are easily erased and never aired in public. (The great majority of my photographs get tossed out.)

Walks like this are my personal search for beauty among the most common man-made objects, and worth it for that alone. They are also my visual alternative to a crossword puzzle; they stretch my brain and amuse me to no end. When I am out walking and taking photos, I'm like a dog that needs to stop and sniff every few minutes to keep present and connected to the neighborhood. My rules are to stay curious, seek out and follow new leads, and keep my cell phone ringer turned off.

I find this practice has compounding benefits, in that the more I look and see, the more I look and see everywhere. Seeing builds on itself. It makes me more curious and increases my engagement with the world. It connects me closer to wherever I am. It forces me to be more mindful. And when I find beauty in simple common stuff, it only heightens my appreciation for beauty all around me. You learn what it is that makes a neighborhood, street, or place more valuable and engaging, such as diversity. Sometimes I'll pick up on some detail like the variations in the ways we solve similar problems; for example, comparing diverse solutions to the use of steps or water fountains to improve public spaces in Rome and seeing how differently other cities incorporate bollards, utility boxes, bike parking, or other common urban elements.

175

far left top
OAXACA ·

left top
SAN FRANCISCO

left bottom
PIETRASANTA

next
TAOS

The practice, for me, is a good antidote for boredom or the blues. It helps me look at the world with a lighter touch, more playfully. Things like decapitated mannequins and pig-and-butcher signage will predictably put a smile on my face. There is often irony, complexity, naïveté, and an underlying humanity to these creations that were never designed to be studied aesthetically.

I often do not know why exactly I am taking photos in any situation, or where I might end up. Take these exposed poles in San Francisco Bay, for example. They actually make a nice rhythmic composition. They might have caught my eye because I had just returned from Venice, where the striped docking poles are an art form in themselves. Sometimes my images make sense when I take time to reflect on them later. Frequently they do not. And that may be the point. The journey is more important than the result.

The simple act of forcing focus and thought on the present has its own rewards. It is a practice that functions very much like physical exercise to keep me in shape. Like yoga or meditation, it suffers if you are not paying full attention. Like making love, it's insulting to do it if your mind is elsewhere. My peak experiences have occurred while I am alone, entirely focused on the immediate, and silent. And it might equally be that I find something as compelling on some everyday street corner or in a café as in some special place like Chartres Cathedral.

If all of us went out on an urban walk with a camera and were asked to take ten photos of anything we found interesting or beautiful, we would see that we all have our own biases and interests. This is a good thing. It accentuates individuality.

Here is a simple exercise. Take your camera out and go find something to focus on. It can be almost anything: a street sign, hubcaps, building details, anything that interests you visually. This practice is often more about developing a point of view than about the object you're photographing. It's about observation and thinking. When you discover something special out there it's like stumbling into a café or shop that was not listed in a tourist guide—your experience of the world is much richer because you did it on your own, without a Yelp review or Google search. And if we learn to see and appreciate the common details in our man-made world, we will be more demanding of our more complex designs and systems, such as our cities.

I put this book together to share not only the way I see the world, but also why seeing, as such, is important. I hope it has inspired you to cultivate your own idiosyncratic and unique way of looking at the world around you. To get out there and see for yourself.